EDISTO

EDISTO

A Guide to Life on the Island

CANTEY WRIGHT

THE
History
PRESS

Published by The History Press
Charleston, SC 29403
www.historypress.net

Front Cover: The day's catch in the cooler, a fisherman uses the last light of day to approach Big Bay Creek's Live Oak Boat Landing at Edisto Beach State Park. *Photograph by Susan Roberts.*
Back Cover: Sunrise at Edisto Beach. *Photograph by Jack Anthonyo.*

First published 2006
Second printing 2008

Manufactured in the United States

ISBN 978.1.59629.155.3

Library of Congress Cataloging-in-Publication Data

Wright, Cantey.
Edisto : a guide to life on the island / Cantey Wright.
p. cm.
Includes bibliographical references.
ISBN 978-1-59629-155-3 (alk. paper)
1. Edisto Island (S.C.)--History. 2. Edisto Island (S.C.)--Social life
and customs. 3. Edisto Island (S.C.)--Guidebooks. I. Title.
F277.B3W93 2006
975.7'91--dc22
2006014564

To the Glory of God

In Loving Memory of S. Ernie Wright
and
McGowan and Sarah Boykin Holmes

In Thanksgiving for Ellen Holmes Wright

In Appreciation for Church of the Apostles, AMiA, Columbia
and
The First Presbyterian Church, ARP, Columbia
and
St. Andrew's Episcopal Church, Mt. Pleasant
and
The Inklings

Contents

Foreword

In the years following World War II, as the natural experience began to be overtaken, we increasingly sought more remote areas for our enjoyment or, as Walt Whitman would say, for the "inviting of the soul." For many South Carolinians, that meant the beach.

When I was a boy, I did not know but one person who owned a house at the beach or, for that matter, a second home anywhere. He was a medical doctor in Columbia. We thought of him as a person of enormous wealth beyond calculation, and we were right about that. His son once invited me to come to the beach for a week. The visit was the high point of my childhood. His house was on Edisto Island, separated from the front beach only by the paved road. Of course, no one at that time would have been so foolhardy as to build a house actually on the beach. We knew better than that, even as children. We had read "The Three Little Pigs."

From that day to this, Edisto Island has been omnipresent in my thinking, if not always in my life. Cantey Wright has captured my feelings for that magical place precisely. From the history, beginning in the year 1520 up to and including what he calls "The Modern Era," to a detailed description of the multiple recreational opportunities, including fishing, crabbing, shrimping, beachcombing and even recipes for cooking what you catch, to the prevailing forces of nature, he invokes in the reader an appreciation similar to mine for Edisto Island.

Edisto: A Guide to Life on the Island

South Carolina's other Sea Islands have been largely overtaken in recent years by two concepts entirely foreign to my experience as a child: gated communities and high-rise condominiums. In my youth, the only people I knew who lived behind gates were either in a penitentiary or on a military installation, and I did not know a single soul who lived in a condominium. In fact, I had never heard the word. Now, gated communities and condominiums are everywhere, particularly at the beach. Much has been lost, but Edisto remains. The island is unique in having largely escaped the kind of development that has prevailed elsewhere. Cantey Wright ends the first section of his book with an eloquent plea:

> *May anyone who attempts to despoil Edisto with high-rises and other high-density developments suffer from corns, bunions, neuritis, neuralgia, the heartbreak of psoriasis and mother-in-law problems. May they also suffer bankruptcy before they cut down three-hundred-year-old oaks or fill the marsh. May they decide to move back to wherever they came from before they build anything that can't be quickly and inexpensively torn down.*

To which we should all say, Amen.

Alex Sanders
President Emeritus
College of Charleston

Acknowledgements

Many friends have, over the last two decades, helped with the book you now hold in your hand. Many are still alive; some have passed on to the other side of the veil. I gratefully acknowledge the assistance of Jack and Caroline Pope Boineau for helping sort out varying dates for some of the historic Edisto homes; my mother, Ellen Holmes Wright for spending many hours researching dates, proofreading, making valuable suggestions and for answering my innumerable questions about what Edisto Beach was like in its early days; Will Cleveland at The History Press for his patience and Hilary McCullough for her great work editing copy; Timmie Dorn for her generosity in letting me stay in her cabin on Edisto when I really needed to get away from it all; Alex Sanders for his wonderful stories and with great appreciation for the foreword to this book; Susan Roberts, not only for the many pictures she took of Edisto for the cover and inside photos, but also for her willingness to go the extra mile to get access to some of the plantations and to shoot them from the same perspective as the Civil War–era photos; Jack Anthony for his beautiful photos, many of which will have to wait until my next book for you to see; Britt Nickels for the photos she took for my earlier book, some of which I am happy to use again; Nancy Lipham for her generous invitation to photograph Oak Island; M.C. Thomas for her corrections of my misunderstandings regarding the age of Edisto fossils; Old Post Office Restaurant folks David Gressette and Peter Sanders, with whom I had the pleasure of working, and

especially Philip Bardin for his long friendship, encouragement, recipes, funny stories and great meals; Dave Buckwalter of Re-Stored Memories for his painstaking work scanning old photos and getting all the book's images ready for press; Betty Kornegay for stopping projects she was already working on to draw the wonderful illustrations of the fish, crab, shrimp and oyster that serve as section heads for the recipes; Christian Minglers Peg and Jen whose strong Christian witness helped me to return to this writing project after I had let it lapse; Janet Jones for her friendship, encouragement, long phone conversations and for her Christian witness also; Frances Mikell Tupper for so many things, including her hospitality, her friendship, her cheerleading me with kind words, and for lending me so much of her private and lifelong collection of Edisto books and articles, and for so much information about the Mikell family and the Peter's Point house; Lieutenant Colonel Bruce and Tecla Earnshaw, whose love of Edisto and respect for its architectural history are inspiring, and for their support and friendship over the years; Mr. and Mrs. Harry Hutson for the pictures of Brick House before the fire; Bev and LeGrand Cooper for their hospitality and shrimping expertise and LeGrand for being the best boss I've ever had; the Edisto Island Historic Preservation Society for all it has done to preserve and protect all aspects of Edisto's past, and for the wonderful museum that they have provided to share it with one and all; and for Jan and Bill Kaneft and the Inklings for all the food, fun, fellowship and great discussions of C.S. Lewis around the backyard fire pits.

Special thanks to my cousin, Edward B. Cantey Jr., from whose philatelic collection he uncovered the letter from a northern tutor on Edisto in the early 1800s, which I quote liberally; to Curt Rogers who found a copy of the Whaley memoir in Tennessee and sent it to me; to Edwin Epps for his valuable booklet *South Carolina Literature: A Reading List for Students, Educators, and Laymen* as well as for his being a good debate role model most of the

Acknowledgements

time and a Southern Comfort to me the rest of the time; and to Charles F. Kovacik for sending me his and Robert E. Mason's paper, "Changes in the South Carolina Sea Island Cotton Industry," which had been published in *Southeastern Geographer*.

I also wish to thank those who contributed to the first book, without whose help this book would not have been possible: Tommy Padgett; Jerome Kizer; Whit Boykin; Marion Whaley Sr.; Marion Whaley Jr.; Mr. and Mrs. Burnet Maybank; Marie Bost; Ann Skipper McAden; Mary Dean Richards; Skeex Clarkson; Frances Johnston; Debbie Mundell; The Edisto Island Sea Turtle Project; Franklin and Caroline Hopkinson Sams; Al McCormack; Linda Flaten; Larry Smith; Dr. and Mrs. Ritchie Belser; Gertrude Bailey Woods; Kirkland Kairos #9; the Reverend Donald Morris; Amy Trowell; Dr. Curtis Worthington; Don Marvin; Jane Murray McCollum; Woody and Cindy Kapp; Tom and Helen Kapp; Henrietta Seabrook Sanders; Mrs. William Edings "Miss Ella" Seabrook; Betty Ann Smith; and Karen Carter.

Introduction

Late in 1988, I self-published *The Edisto Book: A Guide to Edisto Present & Past*. Thanks to a quick sellout of the first five thousand copies, a second printing followed in 1989 and a third printing in 1990. As the result of a personal upheaval, the book has not been printed since. Over the years, I have often been urged to publish an updated and revised edition of *The Edisto Book*. Thanks to Will Cleveland and the folks at The History Press, *Edisto: A Guide to Life on the Island* is just that.

Thanks to many kind friends, I have received documents over the years since the first book was published that have allowed me to expand (and in some cases, correct) information in the first book. I have chosen not to use information that can easily become dated, opting instead to offer a fuller history and to include more recipes. (The recipes were the favorite part of the book for many; cooking one of the recipes on live television resulted in every retailer in the WIS-TV 10 viewing area selling out of the book that day!) Friends and critics (and a few wonderful people who are both) suggested that I focus my efforts on the parts of the book that were the most popular then, and continue to be now: history, leisure pursuits (including recipes) and a nature primer for new visitors to this sea island.

What follows is the essence of what makes Edisto so special to many; I hope you will enjoy the reading as much as I enjoyed the writing.

PART ONE

A Brief History of Edisto

The history that follows is but a thumbnail sketch of the people, their homes and churches, and the events of many generations, long since passed. The search I have been on for the last twenty years has raised as many questions as it has answered, and it has brought me into a closer appreciation of those folks who have gone before me in researching and writing about Edisto. Chalmers Murray, Clara Childs Puckette, Helen Kenner, Nell Graydon, Virginia Tavel and Nick Lindsay are a few of those folks.

What they and I have found is that an enormous amount of "hard" history has been lost to hurricanes, fire, humidity, moths, war and even to carelessness or a conscious effort to bury the past. The "soft" history that remains is found in bits and pieces of documents and in oral tradition. When history is reduced to word of mouth, it takes on a life of its own. One of the greatest difficulties for any of us who have attempted to chronicle the lives and times of Edisto is to sort out these stories and to try to discern the truth from among conflicting versions of the same "facts."

It has been a humbling experience. I look forward to receiving additional information from readers who may be able to correct any of my misconceptions or complete any of my oversights. Rest assured, valued friend, they will find a place in subsequent editions of this book.

Discovery

1520–1666

Before the time of Columbus, Native Americans came and went from this island (some writers suggest that the island was a gathering place for multiple tribes), but eventually a tribe of Cusabo Indians stayed. Enamored by the plentitude of oysters, crabs, shrimp, fish and game animals, this tribe put down roots. The tribe cultivated food crops, most notably corn, and was at peace most of the time with other tribes to the north and west. The tribe is known today as the Edisto Indians.

The first recorded history of the exploration of the island came only twenty-eight years after Columbus's discovery of the New World. In 1520, the Spanish explorer Lucas de Ayllon sailed out of Cuba to what is now Florida, and from there moved up the Carolina coast. His phonetic spelling of the name of the Indians he found there gave the island the first of its many names: "Oristo."

The next year, 1521, another Spaniard, Francisco de Gordillo, landed on the island. He rendered the name "Orista." (Other variations included the French "Audusta," and a multitude of English spellings such as "Edistoe," "Edistow" and even "Odistash." "Edisto" was the spelling that stuck.)

Research on the Spanish period of Edisto's history is sketchy at best, but there is reason to believe that they established a Jesuit mission somewhere on the south side of the island, probably in the neighborhood of what is now known as Peter's Point. If so, the mission did not last. Neither did any French attempts at colonization.

Edisto: A Guide to Life on the Island

Over a century passed before Europeans returned to Edisto. In 1629, England's King Charles I had granted Sir Robert Heath the region comprising the two Carolinas, Georgia and much of Florida under the name Carolina, but no effort was made to colonize the area. Early reports of Carolina so intrigued Charles II that in 1663 he made a grant of land to the Earl of Clarendon and others for the purpose of colonization. Two years later, he extended the grant to include all the land between twenty-nine degrees latitude (below St. Augustine, Florida) and thirty-six degrees thirty minutes latitude (approximately the northern border of North Carolina).

In 1666, Robert Sandford was dispatched to the area with six planters to survey the land grant and investigate its agricultural potential. Sandford was obviously impressed, as his journal shows. He described Edisto Island (which he named "Harry Haven" for one of his seamen) as being full of majestic oaks and luxuriant foliage and by what he described as "fields of Maiz greenly flourishing."

Here, then, was a semi-tropical island, abundant in natural beauty, and showing its great promise as an agricultural Eden by virtue of the fields of corn that the Edistos had so lovingly nurtured. All that remained now was for the island to be settled. That did not take long.

The Colonial Period

1667–1775

Less than ten years after Robert Sandford's report of the richness of Carolina land, the first colonists established Charles Towne (now Charleston) on the west bank of the Ashley River, forty miles north of Edisto. Anthony, Earl of Shaftesbury, was in possession of property on Edisto. Some sources report that Shaftesbury purchased the island, or some portion of it, from the Indians in 1674 for a piece of cloth, hatchets, beads and other goods. However he came by the land, he granted a six-hundred-acre portion of it on the North Edisto River to Paul Grimball.

Grimball, along with his wife and two daughters, settled on Edisto, built a tabby home at what became known as Point of Pines, and thus became the first English settler of which we have record. Little is known of Grimball's first decade on Edisto, other than the fact that he was secretary of the province, and that he was closely associated with Landgrave Joseph Morton (who was governor of the province from 1682 to 1684 and again from 1685 to 1686).

When the Spaniards explored Edisto in the 1520s, they had claimed the land for Spain. Although they subsequently moved their forts and settlements south into Florida, they continued to maintain that claim. When they learned that the English had established settlements on land they claimed belonged to Spain, they resolved to destroy those settlements (Lord Cardross and 148 settlers at Stuart Town/Port Royal, as well as the Grimballs and Mortons on Edisto). In the summer of 1686 three Spanish galleys carrying well over 100

men (and including Indians and Negroes) sailed up to Port Royal, chased the inhabitants out of Stuart Town, then plundered and destroyed plantations, killed livestock and "burnt the towne downe to the ground." Lord Cardross fled north and managed to get to Governor Morton's house on Edisto and warn of the imminent attack. The alarm was not early enough to assemble a defense, however, and the Spaniards looted and plundered the homes of both Grimball and Morton. They burned Grimball's house after taking "loot of great value" (over $100,000 in today's dollars), and several slaves. Remains from Grimball's tabby home can be found to this day.

Governor Morton was even less fortunate. The raiders took "all his money and plate and 13 slaves" (valued in today's dollars at nearly a quarter of a million dollars). They also burned the Morton home and kidnapped the governor's brother-in-law, who was found murdered several days later. Because both Grimball and Morton were in Charles Towne with their families at the time of the raid, they at least preserved their lives. As the size of their losses would indicate, Grimball and Morton were rather comfortably fixed. An inventory of Morton's belongings paints an interesting picture of what life on Edisto must have been like for them in an age when we tend to think of settlers living in log cabins in deprivation. The list includes "eleven mahogany chairs, two elbow chairs and a couch, a mahogany bookcase, two long sconce glasses, card table, a round Tea lavee, pictures of the twelve months in proper dress and the Rakes and Harlots progress, also a harpsichord and a pair of Red and Green enameled china bowls; showing culture and good taste."

The Spanish might have moved next to the fledgling settlement of Charles Towne (founded in 1670) had it not been for "a hurricane wonderfully horrid and destructive," which routed the raiding party by destroying one ship and killing the Spanish commander-in-chief. After destroying Stuart

Town and Edisto and nearly being destroyed themselves by the hurricane, the Spanish raiding party returned to St. Augustine and Lord Cardross returned to Scotland.

PIRATES

Edisto's ninety-five square miles provided over three thousand miles of shoreline along the ocean, rivers and creeks, and this offered safe haven for pirates in search of a place to hide. Most came into St. Helena Sound and up the South Edisto River or one of the major creeks. From there, they worked their way up to one of the dozens of sheltered coves where they could repair their ships, take on provisions and wait for their pursuers to leave. They may even have buried some of their loot.

Early residents of the island were terrorized by these brigands. Either the settlers provided the supplies that were demanded, or what was needed was taken by force. Whether they cooperated or not, there was always the chance that a daughter might be kidnapped, a slave taken or the house burned. It is no wonder then that there were more homes built on the north side of the island in those early days than on the south side. Nor was it surprising that many of the wealthy homes were protected by small cannon.

Not all of the pirate raids were by Spaniards. Some pirates were Frenchmen; some were native Caribbeans, particularly Barbadians; but the majority of those plaguing the area in the 1700s were English. A particularly notorious English pirate was Charles Vane. He was unconscionably brutal and bloodthirsty, and was much feared along the Carolina coast in those days. Vane, by violence and aggression, had amassed a fortune raiding settlements and incoming ships. In the process, he built a small armada of vessels, each in the command of a trusted lieutenant. One of those men was named John Yeates.

Edisto: A Guide to Life on the Island

Yeates entered the Edisto history books when he took the sloop in his command and deserted Vane. He had a full crew onboard, as well as several guns, some slaves and other cargo that Vane had placed on the sloop after a successful raid on an English brigantine outside Charles Town Harbor. Yeates set sail at midnight and headed south toward Edisto with Vane in pursuit. With a faster ship and a head start, Yeates found cover in Edisto's serpentine rivers and creeks and was able to escape his barbarous boss. (Those same rivers and creeks have been a refuge for contrabanders over the years. Much English gin and good Scotch found its way into America by way of Edisto during Prohibition; in the 1970s, marijuana was off-loaded on Steamboat Creek.)

While on Edisto, Yeates decided to turn himself in. Perhaps he feared Vane's retribution; perhaps he came under the civilizing influence of Edisto. Whatever the reason, he requested a pardon from Governor Nathaniel Johnson (governor of the province from 1702 to 1710 and first governor of the royal colony from 1729 to 1735). Johnson agreed, provided that Yeates took an oath of allegiance and that he return the Negroes he had captured.

Raids by pirates and Spaniards may have made it difficult to live on Edisto in those early years, but as Sandford pointed out in his 1666 survey, the island was prime agricultural property. Planters on Edisto first tried rice, but found most of the impounded fields too saline to support the crop. What did grow well was indigo, a plant processed into a rich blue dye which was in great demand in Europe. The English so valued indigo that they paid a bounty for its production. Once an Edisto planter brought in his first crop of indigo, he was on his way to wealth. Thanks to the indigo bounty, great fortunes began to accumulate and Edisto began to develop into one of the most prosperous places in the colonies.

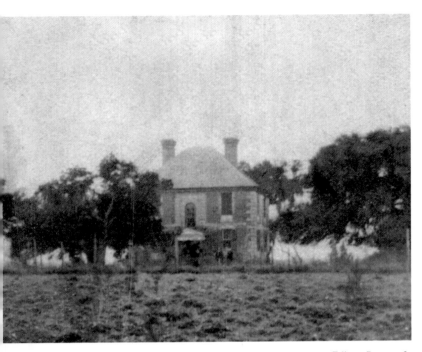

Brick House, built in the early 1700s and now in ruins, is the oldest house on Edisto. *Courtesy of Mr. and Mrs. Harry Hutson.*

EARLY GROWTH

Evidence of this prosperity can be seen in the building of homes and churches. One of the first of which we have record was the construction of Brick House, perhaps as early as sometime prior to 1703, but by most records, between 1720 and 1725. Constructed by master carpenters and artisans, Brick House is considered by many to be the first manor house built in America. Although it burned in 1929, its stately walls (two feet thick) and chimneys bear silent witness to the grandeur and wealth of the early planters.

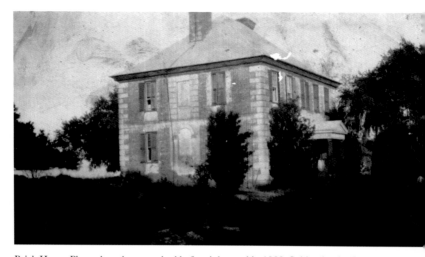

Brick House Plantation photographed before it burned in 1929. Said to be the first manor house in America. The ruins are maintained by heirs of the original owner. *Courtesy of Mr. and Mrs. Harry Hutson.*

As these men and their families built homes and fortunes, they soon felt the need to provide for their spiritual lives. As early as 1706, Edisto Episcopalians were ministered to as part of St. Paul's Parish, Stono. The earliest records of a ministry on Edisto are those of the Reverend David Standish from 1724 to 1728. The Presbyterian Church on Edisto was founded in 1710, and is the oldest uninterrupted Presbyterian organization in South Carolina. In 1717, Henry Bower granted three hundred acres to the Presbyterian Church and in 1722, the church was built. After Lord Cardross's colony on Port Royal was destroyed by the Spanish in 1686, some of the survivors moved north to Edisto, where they worshipped in the same building as the Presbyterians until they built a building of their own.

Just how much the population of Edisto grew during these years of the 1700s cannot be determined, but it isn't unreasonable to think that the

number of residents burgeoned. Estimates for the population of South Carolina show a six-fold increase for the first three decades of the eighteenth century. A similar growth for Edisto would have to be assumed. Not only did the growth of the island demand the services of churches, but also the building of roads and bridges. The needs of transportation and commerce had ceased to be met fully by the waterways, and in June of 1714 there was before the legislature in Charles Town an "Act for continuing the road to Port Royal, and making a bridge over the South Edisto River." Also in that year, a "highroad and Causeway from John Frip's Edisto Plantation to Wilton" was authorized.

Along with more churches, roads and people, of course, come more houses. As far as this history goes, the next house of significance to be built was begun and completed sometime during the period between 1735 and 1760. It is now called Old House, although in earlier days it was referred to as Four Chimneys. It is the oldest house on Edisto that is still habitable.

The growth on Edisto continued into the second half of the eighteenth century, and much of its history is written by the births, deaths, marriages, homes, actions and transactions of a dozen families. One of the transactions on which quite a few of these names can be found at an early date is a 1751 act of the legislature that ordered all of the male inhabitants sixteen to sixty years of age to work on the "cutting, clearing and cleaning [of] 'Watts Cutt,'" an area from Captain William Edings's plantation to those of William Adams and Josiah Grimball.

Whereas many early Edisto settlers had come from Scotland and Wales and were Presbyterians, by the middle of the eighteenth century, more and more English Anglicans were making their mark on Edisto. These early Episcopalians initially worshipped on Johns Island (across the North Edisto River), but by 1770 they petitioned for a Chapel of Ease to be built on the

island. In 1774, the Episcopal Church on Edisto (now Trinity Episcopal Church) built its first church building on the current site.

Less than one hundred years after its founding, Edisto was, in the mid-1770s, a citadel of agriculture and trade. Great wealth was amassed by the indigo plantations that produced the rich blue dye so coveted in Europe. Great homes had been built, churches established and the building of family dynasties begun.

But, as has been the case throughout Edisto's history, this unbridled prosperity was not destined to last. The American Revolution was right around the corner, and with it, the end of the indigo trade and the fortunes it produced.

The Revolution
and the Plantation Era

1776–1860

From its earliest days, Edisto's economy was agricultural and bound inextricably to England. Rice and indigo planters depended on their British factors (who acted as sales/purchasing agents and bankers) for a multitude of services. The factors provided seeds and tools, clothing, furniture and most of the other finished products needed for life in the New World; a market for the goods the planters produced; shipping and financing for the trade; craftsmen and gardeners to build the houses and landscape the grounds of the newly-rich landowners; sometimes found them suitable brides; and occasionally served *in loco parentis* to their sons when they were sent to Oxford or Cambridge.

With so much at stake, it is all the more amazing that the Edisto planters took up the cause for independence with such relish. A 1776 roster for a Voluntary Company of Edisto lists over fifty Patriots, among them many of the most prominent names of the time: Crawford, Edings, Fickling, Hanahan, Jenkins, Mikell, Murray, Seabrook and Whaley.

Although there is no record of any attack by the British on Edisto soil, the island was plagued by its old nemeses, Spaniards out of St. Augustine and English pirates, and by a new threat, "refugee boats" manned by royalists and Mediterranean sailors.

Edisto: A Guide to Life on the Island

As they had since the 1680s, the Spaniards were seeking rice, indigo, loot and revenge. The pirates were mainly interested in hijacking cargo. The refugee Loyalists were looking for all of the above and were also driven by political fervor.

The "refugee boats" were long, low ships very similar to the pirate galleys of the Mediterranean: they carried two cannon (a six-pounder fore; a four-pounder aft), forty to fifty armed men and twenty-four oars as well as sails.

To protect the island from the Spaniards, it is likely that a fort was built some years prior to the war. It may well have been armed with cannon such as the one found in the 1950s by Sammy and David Lybrand, which has been identified as a Queen Anne type made around 1740. It may have been cast in the Tower of London, and it is probable that members of the Edisto Voluntary Company manned this cannon or one like it against the refugee boats while on guard against the Tories.

The Story of Hephzibah Jenkins Townsend

Daniel Jenkins was one of those who joined the Edisto Voluntary Company in 1776, and in 1780, was a captain in that company. Shortly before the British captured Charles Town on May 12, 1780, Jenkins was captured and imprisoned. His wife left Edisto and took up residence in Charles Town to be closer to her husband. Not long before the fall of Charles Town, she gave birth to a daughter she named Hephzibah (from the Hebrew for "my delight is in her"). As was all too common in those days, the birth was a difficult one and Mrs. Jenkins died. As she lay dying, Mrs. Jenkins called her two aged house slaves, Jack and Maum Jean, to her bedside and instructed them to take the newborn baby to the home of her parents (the Jonathan Framptons) on Edisto. Against great odds, the slaves were able to get out of the city, and by cover

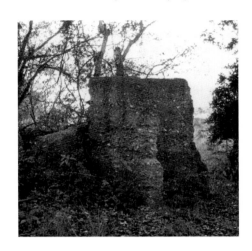

One of several tabby ruins on Edisto. Tabby was a building material made from crushed oyster shells, sand and lime and was used much as concrete is today. Paul Grimball used tabby to build the first home on Edisto and Hephzibah Jenkins Townsend is reputed to have built her bread ovens from the material. *Photograph by Britt Nickels, courtesy of the author.*

of night, they poled and paddled a bateau through the shallow creeks and across the North Edisto River to the safety of the Framptons' home on Edisto. What became of the heroic slaves is not known, but the life of Hephzibah was extraordinary and is one of the best-known stories of Edisto.

Hephzibah Jenkins married Daniel Townsend of Edisto and they raised a large family. Her husband subscribed to the European tradition of primogeniture, in which the entire estate was given to the first-born male child. Hephzibah found this practice abhorrent, and, unable to persuade her husband to make provisions for the other children, became the first woman of her class to go into business.

Hephzibah Jenkins Townsend had tabby ovens built (ruins of these ovens remain at Frampton's Inlet) and she became a baker and a caterer, producing breads for Edisto and nearby Wadmalaw and Johns Islands. She also produced specialty foods for many of the outdoor parties that were so much a part of Edisto plantation life.

Edisto: A Guide to Life on the Island

With her profits, she provided an inheritance for her sons and handsome dowries for her daughters. She also did much for the community. She founded the Home and Foreign Missionary Society, the first such mission of Baptist women in the South, which, in 1811, gave $122.50 for work with the Catawba Indians. She also started the Wadmalaw and Edisto Female Mite Society, another charitable organization.

In 1818, she took money she had made baking bread and had a church built, which was dedicated by eminent Baptist pastor Dr. Richard Furman. At the time of her death in 1847, she gave the church and graveyard (now known as the Old Baptist Church) to the black Baptists on the island out of Christian love, and in gratitude for the actions of the two slaves who saved her life as a newborn.

Sea-island Cotton and the Cotton Plantation Era

With the onset of war with England, commerce on the island was curtailed and the indigo trade collapsed. Although indigo would continue to be grown and processed, the lucrative system of British bonuses ended forever and the profits were never the same. The planters looked for another cash crop, and by the 1790s they were planting a special kind of cotton that would bring riches far beyond the wealth that they had become used to before the Revolution. That crop was sea-island cotton.

Seeds for producing sea-island cotton likely came to Edisto from Barbados, though it is probable that it was first grown in Africa or on the Indian subcontinent. This cotton is a variety that has always been especially valued for the soft fabric that can be woven from its long fibers. One of the popes of Rome insisted that all his cloth garments be made with material from the cotton of one particular plantation on Edisto. The growing range for this

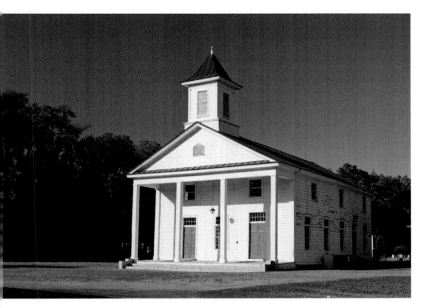

The Old Baptist Church, today. The church was founded in 1730 and the present building built by funding from Hephzibah Jenkins Townsend in 1811. *Photograph by Susan Roberts.*

cotton is quite small—in America, the coastal islands of northern Florida, Georgia and South Carolina—and it was at its best on Sea Islands such as Edisto and St. Helena.

Slaveholding in the South expanded dramatically when cotton became king. Charleston and Savannah were debarkation points for slaves from West Africa and the Caribbean, and both ports did a booming trade with planters eager to increase their acreage and production of "white gold" by purchasing more slaves and more land.

By the turn of the nineteenth century, cotton had become Edisto's number one cash crop. It was an expensive crop to bring in. Sea-island

cotton took longer to grow, required hand labor for every stage of its growth and harvesting, and could not be effectively processed on Eli Whitney's cotton gin. Long-staple cotton had to be fed into a rolling gin by an operator who powered the gin by means of a foot pedal. Slave workers for the cotton fields and gin houses were expensive, but the demand for this soft and silky cotton was so strong that consumers willingly paid whatever price was asked. By the second decade of the nineteenth century, bales of sea-island cotton bearing an Edisto Island plantation stamp commanded and got as much as $2.50 a pound on world markets at a time when upland, short-staple cotton sold for 25¢ a pound. Edisto plantation owners became fabulously wealthy. Cotton money built and furnished fine homes on Edisto and in Charleston, paid for excellent educations for the planters' children (first by tutors and then on to higher education at Oxford, Cambridge and other European universities) and made possible a lifestyle of gentility and leisure.

As sea-island cotton became the most important cash crop ever, seed selection became more important and was usually a tightly held secret. Whitemarsh Seabrook, however, thought that the more that was known about cotton agriculture, the better. "He wrote the book," is more than just a saying in Seabrook's case. The full title of his treatise on cotton says it all: *A Memoir on the Origin, Cultivation and Uses of Cotton, From the Earliest Ages to the Present Time, with Especial reference to the Sea-Island Cotton Plant, Including the Improvements in its Cultivation, and the Preparation of the Wool &c. in Georgia and South Carolina; Read Before the Agricultural Society of St. John's Colleton, November 13th, 1843, and the State Agricultural Society of South-Carolina, December 6th, 1843, and By both Societies ordered to be published. By Whitemarsh B. Seabrook, President of the State Agricultural Society of South-Carolina.* Seabrook, it should be noted, became governor of South Carolina a few years later.

Members of the Seabrook family were highly regarded and very wealthy. They and the Whaleys, Baileys, Murrays, Mikells and Edings brought so much wealth to the island that it became what author Clara Childs Puckette called "A Sea Island Principality."

WILLIAM SEABROOK

If Edisto was a principality, then William Seabrook was its ruling prince. In him there was a convergence of intelligence, education, breeding, charisma, motivation, opportunity and wealth, which produced success and resulted in a beneficent, princely power. Seabrook was an acknowledged master of cotton seed selection and horticulture in general.

One of the first things the planters did with their newfound wealth was to construct homes worthy of their position as lords to the court of king cotton. Of all the wealthy planters on Edisto, William Seabrook was the wealthiest and is said to have owned 1,500 slaves. Sometime between 1808 and 1814 (1810 by most sources), Seabrook built his majestic home on Steamboat Creek and surrounded it with stately formal gardens and distinguished outbuildings.

The house may have been designed by James Hoban, the architect of the White House, who lived in Charleston just prior to the turn of the century. The house is commonly accepted as the prototype for one of two architectural designs used almost exclusively throughout the Lowcountry in the antebellum period. (On Edisto, examples of homes patterned after Seabrook House include Oak Island, which was built for Seabrook's son circa 1828, and the Mikell House at Peter's Point, circa 1840.) The William Seabrook House (also referred to as the Dodge Plantation for its later owners) remains to this day as a testament to the grandeur of that bygone era.

Edisto: A Guide to Life on the Island

The William Seabrook House is distinguished by a double-tiered portico half the width of the house, and by double front steps. The steps rise toward the front face of the portico and reach paired landings seven steps up. From the landing, four steps rise toward a center landing decorated with an ironwork railing bearing William Seabrook's initials.

The first floor features a spacious front hallway and a slightly smaller back hall (the two are divided by an elegant archway) from which rises a double staircase. On either side of the hallway are one large room to the front and a smaller one to the rear. Each room has at least four large windows (the front rooms have five), ensuring cross ventilation during the warmer months. Two large chimneys serve fireplaces in each of the downstairs rooms to provide winter warmth.

Landscaping included an oak-lined double front driveway, formal gardens, a small fishing pond and a gazebo. To the left of the house are a handsome brick carriage house and a hothouse, the latter of which is still in use. The second floor of a gin house on the property has been turned into guest rooms, the ground floor used as a garage and utility storage area. I painted the gin house in the 1980s, and you'll never catch me that high up on a ladder ever again.

The house is built close to Steamboat Creek and has nearly as impressive an appearance from the back side as from the front. This two-faced building technique was one of the often-copied features of the William Seabrook House, and for good reason: most guests in the 1800s came by water.

It was here, in 1825, that Seabrook and other planters met and entertained the great French general of the American Revolution, the Marquis de Lafayette. It was more than coincidence that, when Lafayette toured the country for which he had fought so gallantly, he would come to Edisto and to the Seabrook home. Lacking only Old World titles, Seabrook was a ranking member of this country's southern cotton plantocracy and he and Lafayette

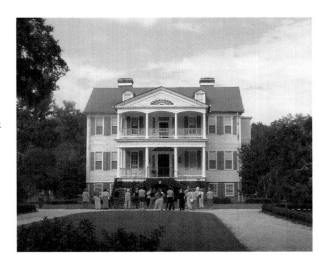

The William Seabrook House (front view) during an annual tour of homes sponsored by the Edisto Island Historic Preservation Society. *Photograph by Susan Roberts.*

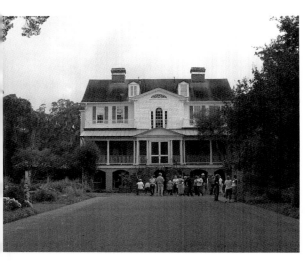

Rear view of the William Seabrook House during an EIHPS tour of homes. LaFayette was feted here. *Photograph by Susan Roberts.*

37

were peers of sorts. At the grand ball and reception held for the general, Seabrook asked Lafayette to do him the honor of naming his new daughter. The general obliged and the infant was christened Carolina Lafayette.

She would eventually marry James Hopkinson and, while on their wedding trip to Europe, the honeymooning couple was entertained in Paris by the family of the late general. In fact, this relationship between the two families continued, with another of William Seabrook's daughters marrying the Count de Lastaigne, and George Lafayette coming to America to visit the Hopkinsons at Cassina Point (which Hopkinson had built as a wedding gift for his bride).

The William Seabrook house and Cassina Point were only two of the many fine homes built during the historically and architecturally significant period between 1800 and 1850. Although exact dating of many of the houses is not possible, it is known that a disproportionate percentage of the ones we know about were built during that time of incredible prosperity for the island. A later section of this book lists the homes, gone or still standing, with estimated dates and alternate house or plantation names.

Waterways were the primary means of commercial transport. Steamboat Creek was so named for the daily steamboat traffic from Edisto to Yonges Island, Toogoodoo, Rockville and Charleston. From the late 1700s right up into the early decades of the twentieth century, Steamboat Landing was the center of activity and commerce on the island.

Oak Island

Iconic planter William Seabrook built a home in the late 1820s or early '30s for his son, William E. Seabrook Jr. He named it Oak Island, for the fine old trees that are still visible on the grounds today, and he presented it to his son

and his son's new bride, Martha Washington Edings. It remains as an elegant example of homes built in the Georgian style. While not as grand as the senior Seabrook's home, Oak Island more than compensated for any lack of grandeur with its extensive formal gardens.

In her memoirs written shortly after the Civil War, Martha Seabrook catalogued some of the grander features of the landscaping, which was planned and executed by an Englishman hired and brought to Edisto for that sole purpose. "There were," she wrote, "lawns encircling the house, out-buildings of every description, camellias of every known species, 1,500 varieties of roses, an aviary, and a large fish pond, in the middle of which stood a latticed house covered with roses. A rustic bridge crossed to the island."

From the grounds of Oak Island, it is possible to see Cassina Point Plantation just across Oak Island Creek to the south. The Intracoastal Waterway is visible across the marsh to the north, and Wadmalaw Island can be seen beyond the North Edisto River directly to the east.

After the fall of Port Royal to Federal troops in November 1861, the Confederacy ordered Edisto Island and other coastal areas south of Charleston to evacuate. Shortly thereafter, Federal troops landed on the island. Many of Edisto's plantation homes, particularly those on the north side of the island, were occupied by Union troops during the war. Oak Island was one of these, and it is believed to have been used from 1862 until 1865 as one of the two or three headquarters of the occupation forces. Soldiers of U.S. Army regiments from Ohio, Massachusetts and New Hampshire were garrisoned here during that period.

The planter families had so little warning at the time of the evacuation order that most of them left the island without many of their possessions. All of Oak Island's fine furnishings, all of the art and all the books were left behind. An attempt was made to hide some of the valuable silver and china

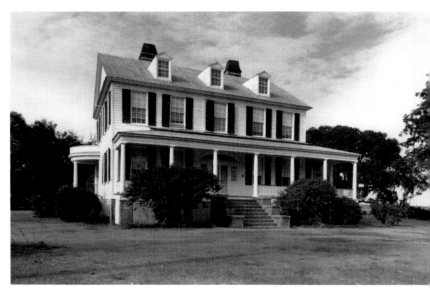

Oak Island Plantation, built by William Seabrook as a wedding gift to his son in 1828. The property has always been known for its exceptional flowers. Present-day owner Nancy Lipham is the first non-family member to own the home. *Photograph by Susan Roberts.*

by burying it, and it is even thought that perhaps some family treasures were thrown into the well that still stands out in the north yard today. But nothing was ever recovered and a fortune was either stolen and carried away by the Federal troops, or destroyed later by the freedmen who occupied the house immediately after the war.

None of the current furnishings in the house are original. It is interesting to note that while they occupied the plantation, the Union troops took extensive photographs. Many of these photographs have survived and today serve as a reminder of the past splendors of Oak Island, particularly of the formal gardens. Federal troops also left marks of their occupation carved in

the white plastered walls in the attics of both Oak Island and Cassina Point. It is also interesting that unlike most plantation homes, Oak Island remained in the family up until just recently. Mr. and Mrs. Parker Connor were the fifth generation of Seabrook descendants to live in the house. It is now owned by Nancy Lipham, who treats the property with the same respect one might expect were it still in family hands.

Historic Homes in Overview

There are very few places in the American South where there are as many antebellum homes still intact as Edisto Island. The Federal Army, by using Edisto's homes for lookout posts, headquarters and the garrisoning of troops, preserved the structures at a time when many elsewhere were put to the torch. The contents of the houses, however, did not fare as well, with much of the silver and fine furnishings looted, and much of the furniture that was left burned by the freedmen for warmth and for cooking fires. The years that followed the end of the war saw most of the plantation owners returning to their homes, but they were utterly devastated financially by the end of slavery. Fields that once produced incredible wealth from indigo, rice and cotton now were worked by the owners for much smaller yields and profits, and for sustenance crops. Many of the island's acres had also been given to freedmen and no longer provided riches for the plantation owners. While this was a blow to the plantations and their owners, many freedmen achieved a middle-class existence and sent their children to be educated so that they would not have to work the land.

Edisto limped forward through Reconstruction and into the twentieth century, a shadow of its former self. During this time, some homes were lost to neglect and others to fires. The entire village of Edingsville was destroyed by

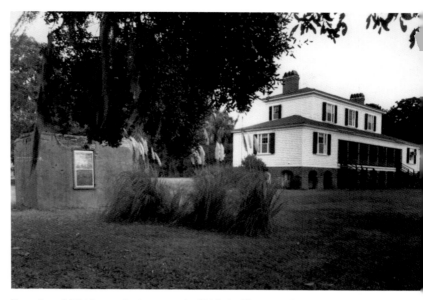

Rear view of Middleton, also known as the Chisholm House, the Launch, the Pope House and (incorrectly) Middleton Place. The stuccoed brick outbuilding to the left was used as an office by Dr. Pope. *Photograph by Britt Nickels, courtesy of the author.*

a hurricane. Many of the once-fine homes stayed in family hands; others were saved and restored by folks from the North who bought the properties as winter getaways or hunting grounds. The "Sea Island Principality" would never again see the wealth it had become accustomed to before the Civil War.

A listing of the known homes on Edisto is surprisingly long:
 Grimball House Tabby Ruins: circa 1674–86; destroyed by Spaniards, 1686
 Brick House Ruins: 1720–25; gutted by fire, 1929
 Old House (Four Chimneys): 1735–60
 Seaside (Locksley Hall): circa 1802

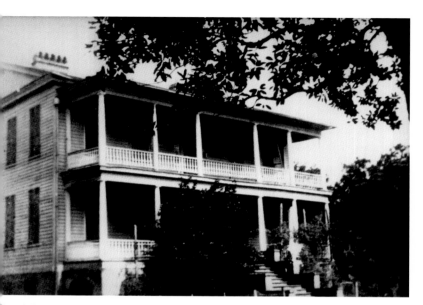

Peter's Point, the Mikell home, was built by Isaac Jenkins Mikell in 1840. Restoration of this exceptional home began in the 1980s. The home is still owned by Mikell heirs. *Courtesy of Frances Mikell Tupper.*

Brooklands (Brookland): circa 1807

William Seabrook House (The Dodge Plantation): circa 1810

Middleton (The Chisolm House, The Launch, The Pope House): circa 1815

The Bailey House: 1825

Bailey's Store: 1825, moved from Edingsville sometime prior to 1893

Oak Island: 1828

Crawford Plantation: 1830

Presbyterian Manse: 1838

Peter's Point (Point St. Pierre, the Mikell House): circa 1840

Cassina Point: 1847

Bleak Hall Ice House and other buildings: circa 1850

Edisto: A Guide to Life on the Island

The Greenspoint House at Point of Pines: 1850
Swallows Bluff at Point of Pines: 1850
Windsor Place (The Swinton Whaley Place): 1857
Sunnyside: 1870–80
Prospect Hill: 1878

These homes are no longer standing:
Frogmore: destroyed
The Neck: destroyed
California: destroyed
The Tom Seabrook Place: destroyed by fire
Pine Baron: destroyed by fire
Blue House: destroyed by fire
Laurel Hill: destroyed by fire
Old Dominion: destroyed by fire
The Charlie Seabrook Place: destroyed by fire
The Edings Place: destroyed by fire
Shell House: destroyed
Gun Bluff Plantation: destroyed by fire
Bleak Hall: destroyed by fire, circa 1850
Bleak Hall re-built: torn down
Sea Cloud: torn down
The Hopkinson House: destroyed

A Christmas Oyster Roast at Botany Bay

If it sounds like the age of the cotton plantations was extraordinary, it was. Reading through Edisto history—primary documents as well as

memoirs and tales—gives the reader a sense of how these wealthy planter families lived. A composite can be drawn from Nell Graydon's *Tales of Edisto*, I. Jenkins Mikell's *Rumbling of the Chariot Wheels* and even a chapter in Richard Barry's *Mr. Rutledge of South Carolina* of what a Christmas season on Edisto might be like. One such gathering took place on December 27 (we do not know the year) at Botany Bay hosted by the owners of Bleak Hall. A monumental effort went into preparing the grounds for the feast and the food for the guests.

The first job required of the host was to improve the condition of the road leading to Botany Bay. Days were spent smoothing the roads and improving the bridges so that on the appointed day, the carriages of the guests could get to the site of the banquet. While crews of slaves were attending to this task, others were cutting and hauling cords of hickory, oak and cedar, which would be used for the cooking fires. Still other crews were searching for and cutting young palmettos, the hearts from which would be transformed into the much-prized delicacy palmetto cabbage (similar to what modern diners may know as hearts of palm, and which Mikell aptly describes as having "the combined taste of cauliflower, burr artichoke and asparagus, with a most fascinating predominant taste of its own").

Yet other crews labored to build long tables and benches, each of which could seat two dozen. Roasting pits were constructed for the oysters, venison, beef, hog and wild boar that would be served at the huge outdoor banquet. Giant iron kettles were set in place for cooking diamondback terrapin stew. Elsewhere on the island, oysters were gathered, brought back to the plantation, and kept in an enclosure in the creek, ready to be conveniently removed at the last minute for the roasting. These were the fabulous White Foot oysters, named for an early tribe of Edisto Indians, and considered to be the best oysters on the Carolina coast.

Edisto: A Guide to Life on the Island

As was the tradition on the plantations of the era, the "oyster roast," as the entire event was called, began with the arrival and seating of the guests at 1:00 p.m. By this time, all of the Bleak Hall servants had been working feverishly for many hours. Their preliminary work accomplished, they now proceeded to serve the roasted single oysters to each guest. Everyone had a linen placemat, a cloth and an oyster knife in front of them.

The butler served steaming grog from a silver pitcher. The hot punch was, as Mikell described it, "old-time-knock-down-drag-out whiskey punch; not your Manhattan or Bronx poison, but punch made of lemons, hot water, sugar and double-proof, imported Irish peat whiskey."

The guests ate and drank for an hour and then removed themselves from the tables. What followed was an intermission of sorts, during which the men walked along the beach, talked of politics and cotton, and smoked their long, imported cigars. The women gathered in small groups and chatted, or sat on the porch and rocked.

The intermezzo lasted for an hour. While the guests allowed the first course to settle, the servants stripped the tables, cleaned and dried them, and laid out fresh white linen tablecloths and sterling silver flatware and serving pieces. The main course of the "oyster roast" was served at 3:00 p.m. And what a feast it must have been! Some of the food was cooked on site (the roasted meats, the terrapin stew), but much of it was cooked in the plantation kitchens and brought to the banquet in "fireless cookers" in the beds of "rapidly driven wagon[s]."

In addition to the palmetto cabbage, guests dined on crayfish in aspic, shrimp and watercress salad, whole baked snapper in Bordeaux sauce, a pudding made of sweet potatoes and palmetto hearts, venison patties, mincemeat pies, pumpkin pies, sweet potato pies, pickles and relishes of near-infinite variety, spoonbread and other dishes we can only guess about. The dining lasted for

hours with fine French wines accompanying. Those days are now history. Or perhaps it's more than that. Perhaps we should call it legend.

THE BAY AT EDINGSVILLE

Another legend of Edisto's Golden Age was "the Bay." One of the notable aspects of Edisto plantation life was that the planters and their families maintained two residences on the island. From late fall to spring, they lived at their plantation homes scattered from one end of the ninety-five-square-mile island to the other, but for the warm months, the families lived together in a village on Edings Bay, also called Edingsville, or simply "the Bay."

There is only a narrow strip of sand left now between the marsh and what was the Bay, but in the 1800s, Edings Bay was a wide expanse of high ground behind large sand dunes and an expansive beach. The village the planters built there boasted forty to fifty two-story homes, two churches, at least one rectory, an academy, a general store, a billiard saloon and cisterns for fresh water. Fruit trees were planted and picked, cattle was raised, pigs were penned and chickens ran free. Goats pulled youngsters in carts, and life on the Bay was grand.

The reason the families moved to the beach in the summer was not merely for fun and fellowship. Malaria and other "fevers," as they were called, were a constant menace to the plantation families and many died from the fevers. What we know now that they did not is that the anopheles mosquito is the carrier of malaria, and the plantations on the island were swarmed with them during the hot months of summer. At the beach, the sea breezes protected the residents from many of the illnesses that afflicted them at their plantation homes. So each May, the planters would load up their beds and many of their household goods onto wagons and ox carts and move into their summer homes. The men continued to visit the plantations almost daily, but the

Edisto: A Guide to Life on the Island

women and children made the Bay their exclusive homes for at least half of each year. Lest any young readers become too enamored of a summer at the beach, the children of that era attended school twelve months a year.

That the Bay was a special place cannot be denied. Lavasseur, the secretary to Lafayette, commented on Edingsville in his 1824 visit, praising the Bay's "beautiful palm trees, which gave to the...dwellings they shaded an aspect altogether picturesque." Five years later, a young man from the North who was tutoring the children of "some four or five planters" would write to a lady friend in New York:

> *I believe Edisto is one of the pleasantest spots of the South—It is quite as healthy as any part of the Low Country of the South and there is a Bay at the Southeast of the Island, where the Planters reside during the unhealthy months, which is perfectly delightful. Most of the Planters move to the Bay, about the first of June and remain until the start of November. I shall go next week. The Bay I am informed is a very gay place. There are about 50 families residing there in Summer, having nothing to do but to enjoy themselves. The place itself is perfectly delightful. The waves of the Atlantic Ocean are eternally rolling upon a beach 5 or 6 rods wide and as many miles long. This beach is perfectly hard and the most beautiful place to walk or ride in the world. They take the most delightful fish directly in front of their residences, and in the inlet in back are thousands of the most delightful oysters. Nothing would tempt me to live during the warm months, in any other part of the South that I have visited. The Bay is very healthy. There is a continual sea breeze.*

I. Jenkins Mikell described the Bay quite well in *Rumbling of the Chariot Wheels*: "One might enjoy the luxuries of the plantation, about six or seven

miles off, the social intercourse of a village, and the gayeties of a bathing resort. Life then and there was one summer's dream. There the art of being busy and doing nothing was brought to a fine point by most of the younger planters."

Cecil Wescott (also spelled Wescot or Wescoat), a late nineteenth-/early twentieth-century artist from Edisto, painted this verbal picture of Edingsville: "Oh, it was," he rhapsodized, "a grand and glorious place. I never hope to see another like it short of heaven."

For all its glory in its heyday, the Bay would be a different place once the Civil War began. What the war and Reconstruction didn't destroy, the weather did: the Bay was totally destroyed in a monstrous hurricane in 1893, leaving only a sliver of beach where the village used to be.

DUELING

The plantocracy, the planter elite, lived a life we might fairly call a Camelot, and like it, men and women behaved by a strict code of living in which women were venerated and men lived by and for the concept of honor. It was this sense of honor that led to an extraordinary affinity for the ***code duello*** and its end product, the duel to the death.

Long after duels were outlawed, they continued to be a way of life for young Edistonians, both on the island and during their trips abroad for education and adventure. I. Jenkins Mikell tells of one such event, the Bailey/Gilling duel, in his memoir. It took place where most Edisto duels were held, at the Sands, a sandy spit of marsh flat on Edingsville. For reasons lost to time, Arthur Alfred Gilling, a native of London and a crack shot, challenged one of the Bailey clan (which one is lost to the ages) to a duel. Bailey was a notoriously bad shot, but accepted the challenge rather than sully his and his family's honor.

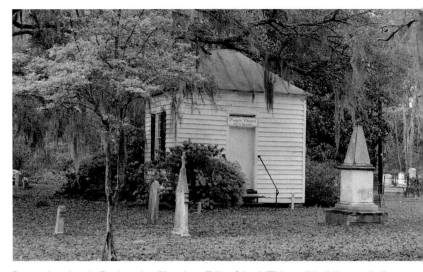

Prayer chapel at the Presbyterian Church on Edisto Island. This small building was built around 1800 and used for meetings of the Session in years past. *Photograph by Susan Roberts.*

On February 12, 1839, Bailey and his second went to the Sands for what all Edistonians thought would be Bailey's last day upon this earth. As the story has it, Gilling was so sure of the outcome that when he raised his pistol, he waited for Bailey to take the first shot. There is no way to know who was more surprised, Bailey, Gilling or the spectators, but when the sulfurous smoke cleared, Bailey was standing and Gilling, twenty-eight years old, had fallen with a mortal wound. Gilling was attended by Bailey's own physician whom he had brought with him to the duel. When Gilling was pronounced dead, he was placed on a mattress Bailey's friends had dragged to the Sands for the purpose of returning Bailey's body home for a proper burial. Bailey, ever the gentlemanly man of honor, saw to it that Gilling was buried in the Presbyterian churchyard, and even paid for the tombstone that rests over his mouldering bones to this very day.

Bailey fought and survived but one duel. Edward Whaley survived seventeen. Twenty years after the Bailey/Gilling duel on Edisto, Edward Whaley fought the first of his seventeen duels. Edward Mitchell Whaley was born at Edingsville, Edisto Island, on October 15, 1840, to William Whaley and Rachel Mitchell. The senior Whaley was a planter, a lawyer, a state senator and later, a major of state troops for the Confederacy. The younger Whaley, like so many of his era and class, spent the first two decades of his life in education and leisure. After tutoring on Edisto and preparatory classical school studies in Charleston, his parents thought Edward too young (at fifteen years old) and too wild to attend South Carolina College. They sent him abroad with an uncle only four years his senior, hoping the trip would prepare him for university studies.

As a student of the University of Berlin, Whaley had the first of his duels. In his memoir, Whaley says,

> *It was with a sword I was unused to, called a "clocke." I managed in this duel to come out slightly wounded but having fought out the stipulated rounds. This was strictly a "Fox Duel" or student's duel. While at the University I had seven other duels—the last of which was with a celebrated swordsman and fought at Leipsic* [sic]. *It was with a large man, six feet and over, and I expected to be used up quickly. I overheard him say while things were being prepared for the fight "I will soon finish that young Yankee." This was said in German but that is what it meant. I felt uneasy as this duel was with broad swords and not a mock duel. I felt slightly nauseated but I had made up my mind to go through with it. It did not last over one minute but it seemed to me to be ten or more. He made a feint at me to put me off my guard. Fortune favored me, I took immediate advantage and cut him down and out—a terrible cut from left*

eye through face and into heart. Our doctor told me to leave and said it significantly and I did so.

After fleeing to Paris, Whaley returned to Germany, but this time to Heidelberg where he matriculated as a law student and joined the Westphalian corps, of which he became second officer. Whaley says that while part of this corps, he "fought ten duels—in the eighth of which I was cut down, receiving a severe and dangerous cut across the nose and entire face."

While in Europe, the Civil War began and Whaley began a harrowing and nearly life-ending trek to return to South Carolina. Once home, he joined the Confederate military and two years later, as a second lieutenant in Company B of the First South Carolina Infantry, took his turn as Officer of the Day at Fort Moultrie. He was embarrassed to find that the password for the day was "cut-nose." As it turned out, he had met with the colonel earlier that morning and when the adjutant asked the colonel a short time later for the daily password, the first thing that came to the colonel's mind was "cut-nose" after seeing the red mark over Whaley's nose, the lasting scar of that German duel.

Churches

During the early 1800s, Episcopalians and Presbyterians, who had their own churches back up on the island, worshipped in the same building (a former academy) at Edings Bay. By 1821, the Episcopalians had built a parsonage on the Bay and in 1824 the two groups agreed to build a new structure in which to worship. Disagreement over a reading desk caused an amicable separation of the two denominations, with the Episcopalians buying the building (which was consecrated in 1826 as St. Stephen's Chapel) and the Presbyterians building another church on the beach around 1825.

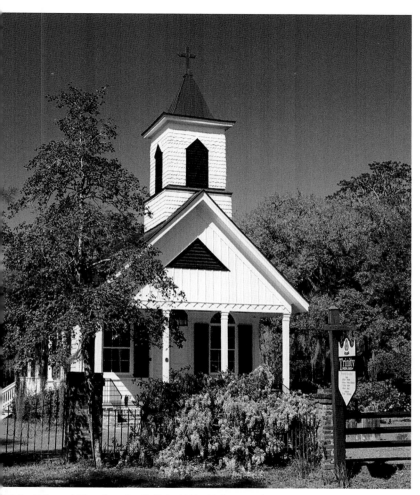

Trinity Episcopal Church, today. Built in 1880, this is the third building on the site, the first having been built in 1774. The second was built in 1841 with a gallery seating two hundred and a steeple one hundred feet high. *Photograph by Susan Roberts.*

Edisto: A Guide to Life on the Island

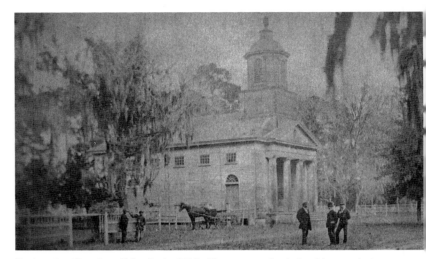

Presbyterian Church on Edisto in the 1800s. The congregation is the oldest continuing Presbyterian congregation in South Carolina. This structure was the second built on the site. *Courtesy of the Mikell Collection.*

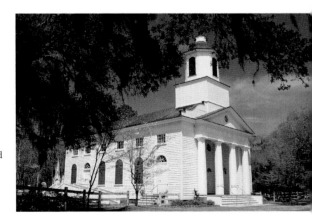

The Presbyterian Church on Edisto Island, today. The congregation was established in 1710 and this structure was built in 1830. *Photograph by Susan Roberts.*

By 1830, the Presbyterians had outgrown their church back up on the island, and the second building (the present one) was constructed. The Episcopalians followed suit in 1840, and in 1841 Bishop Gadsden consecrated the new church. During its construction, the Episcopalians worshipped in the Baptist Church, and in appreciation, a pew was set aside for Hephzibah Townsend for the duration of her lifetime. Sadly, the 1841 church was destroyed by fire in 1876 and replaced by the existing building in 1880.

The lifestyle that the planters had enjoyed was only possible because of the great wealth produced by sea-island cotton, and as Edisto planters prospered, they turned every available acre of arable land to cotton. But with the growth of agriculture and the opulent living it afforded, there was an ever-increasing need for slaves. In the very heart of their prosperity were sown the seeds of their downfall. Just ahead would be war and a depression that would last for eighty years.

The Civil War

1861–1865

Neither the pirate raids, the Revolutionary War nor the collapse of the indigo trade that preceded, nor even Reconstruction, hurricanes, earthquakes or the boll weevil infestation that followed, had even a fraction of the destructive impact on the economy of Edisto that the Civil War had.

The War Between the States, as it was most commonly called, began forty miles north of Edisto with the bombardment of Fort Sumter in April of 1861, but its roots go back almost three decades to the seeds of secession sown by John C. Calhoun in the 1832 nullification issue.

William Aiken, an anti-secessionist from Jehossee (connected to Little Edisto until separated by the Watt's Cut) was elected governor in 1844. By 1848 feelings of anger toward the North's treatment of the South had intensified to the point that another Edistonian, this one a proponent of secession, was elected. He was Whitemarsh Benjamin Seabrook, an intellectually gifted member of Edisto's cotton plantocracy and an eloquent orator (he gave the welcoming address to Lafayette on his 1825 visit to Edisto).

Calhoun's death in 1850, and the great mourning surrounding his funeral and burial in Charleston, served to further solidify emotional support for states' rights.

The effect of this great sentiment culminated in the Secession Convention of 1860, held in December in Columbia. It was at the convention that

Edisto's delegate, Joseph Jenkins, took the floor and whipped the gathering into a frenzy with his moving statement that if South Carolina did not secede, Edisto would! Rallying behind Jenkins, the group voted to secede, making the state the Commonwealth of South Carolina and the first state of what would become the Confederacy.

Twenty days later, Confederate forces at Charleston fired on the Federal supply ship *Star of the West*. Four more months passed in uneasy quietude before, in April of 1861, Fort Sumter was fired upon and the Civil War began.

Many of Edisto's men put on the uniform of the Confederacy that spring and left the island to fight in places as near as Adams Run or as distant as Manassas and Fredericksburg. But life on the island remained relatively normal through the spring, summer and early autumn of 1861. But on November 7 of that year, a battle took place that would change Edisto forever.

On that day, fifty-two steam-powered Union warships and twelve thousand men had met and defeated a much smaller Confederate force at the Forts Beauregard and Walker in Port Royal Sound just south of Edisto. After assessing the impact of this great loss, General Robert E. Lee ordered the evacuation of the coastal zone from Charleston south.

With little notice, Edisto's plantation families did not have much time to make arrangements to protect their property. They grabbed as many of their valuables as limited time and space permitted and headed inland to the upstate, many of them taking their household slaves with them. Left behind were the houses and their lovely furnishings, and the year's crops.

As the planters moved out, the Union forces moved in; Edisto was occupied by Federal troops for the duration of the war, and during those years an armada of ships made their way from Edisto to the North loaded with

Above: Cassina Point, the plantation home of Carolina Lafayette Seabrook and her husband James Hopkinson. The house was built as a wedding gift. Photographed by a Federal soldier in 1862. *Courtesy of the New York Historical Society. Below*: Cassina Point Plantation, today. Lieutenant Colonel Bruce and Tecla Earnshaw purchased the home in November 1987 and have since done a total restoration. *Photograph by Susan Roberts.*

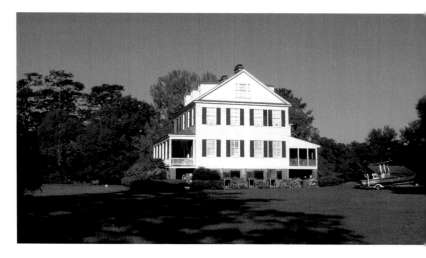

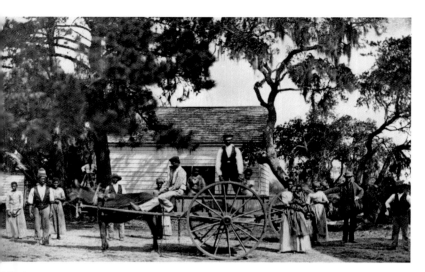

"Gwine to da Field." Made in 1862 by Henry P. Moore of Concord, New Hampshire, on the Edisto Island plantation of James Hopkinson (Cassina Point). Some sources reckon there were as many as ten thousand freed slaves on Edisto for a time. *Courtesy of the National Archives and Records Administration.*

furniture, silver and other valuables from the homes of the exiled planters.

Even the churches were not spared. The organ and many other valuables were taken from the Presbyterian Church and shipped to the North. The Episcopalians even had their Bible stolen, though in later years a guilty conscience led to its return to the family that had originally made the bequest.

During their stay on Edisto, Union troops also desecrated many of the homes in which they were quartered with drawings, writings and other graffiti; some still remain and can be seen in the basement of Cassina Point.

But perhaps the greatest indignity was perpetrated by one of the North's greatest heroes. William Tecumseh Sherman, whose name is even now spit out with the distaste of spoiled milk, had reached Savannah by 1864 with tens of thousands of newly freed and helpless Negroes in tow. Aggravated

Edisto: A Guide to Life on the Island

by the responsibility of helping these people for whom he supposedly fought, and eager to get back to the serious business of destroying lives and property, Sherman issued orders seizing all of the Sea Islands and directing that the multitude of Negroes with him be settled there.

Without the assistance of the Freedman's Bureau (which would come later), an army garrison on the island took on the incredible task of somehow feeding, clothing and housing the ten thousand poor souls who were sent to Edisto. The result was disastrous: hundreds died from exposure, hunger and untreated illnesses. Those that didn't die were crammed into homes, slave houses, stables or any structure with a roof.

Thus by 1865, Edisto had become little more than an inadequate warehouse for thousands of freedmen. Help would come, but for the majority of people on the island, that well-meaning assistance would be too little, too late.

Reconstruction
and the Long Depression

1866–1940

Several of my friends, on reading the chapter titles for this book, commented that they had never heard of "the long depression" and thought eighty years sounded like an awfully long time. I chose to name the period "The Long Depression" after considering the following: what the Yankees didn't steal and the Negroes didn't burn for firewood was inundated by the hurricane of 1865; the crops that still existed were ruined; in 1866 heavy and continuous rains caused flooding and the crops rotted; 1867–70 were no less disastrous, according to a long article in the *Charleston News and Courier* in April 1880.

When Union troops moved onto Edisto after the evacuation order early on in the war and the thousands of Negroes followed, issues arose that had never been expected or planned for. First was the matter of health, and as mentioned earlier, disease was rampant. Then there was the matter of food. Many of the Negroes had worked on cotton plantations along the southern South Carolina coast, but they couldn't eat cotton. Much of Edisto's arable land was "in cotton," as they used to say, but very little had been cultivated for food crops. Even if the Negroes had wanted to plant sustenance crops, the supplies of seed just weren't available. Education of the former slaves was a priority for Northerners, and they sent groups of teachers to the island. Some of the old homes were used as schools and others to house the teachers, but

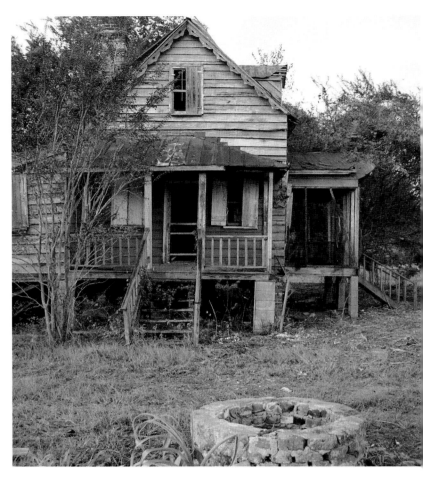

Freedman's house and well on Point of Pines Road. The Hutchinson House is the oldest surviving freedman's house on Edisto Island. It is thought to have been built in 1885 as the home of Henry Hutchinson, who was born a slave in 1860, and his bride, Rose Swinton. *Photograph by Susan Roberts.*

the fact was that food and shelter were much higher priorities for those who were displaced to the island. By the end of the war, Edisto was just barely holding on.

Some of the freedmen did survive and prosper, building homes, farming the land, including cotton (sea-island cotton was still highly valued on world markets) and educating themselves and their children. But the storms and floods that followed severely curtailed any hope of a return to agricultural productivity for whites or blacks.

Other calamities continued throughout the decades following the war. In 1876, the Episcopalians lost their lovely church to the ravages of fire. In 1886, the island was rocked by a major earthquake; 1893 saw the tremendous power of a hurricane wipe Edingsville and its houses into the Atlantic. *The Marion*, a passenger ferry, burned and sank in 1907 with forty-five casualties, many of them Edistonians.

Once again, in 1911, a hurricane struck, causing not only property damage but also the loss of the year's crops; 1914 will be remembered as the year the boll weevils entered onto the Sea Islands from Mexico.

Many planters lost their sons in 1917 and 1918 in the "Great War" and lost their crops to the "Great Boll Weevil Infestation" of 1914–20. Long-staple cotton ceased to exist. No sooner had Edisto started toward recovery by planting short-staple cotton than it was staggered by the Great Depression. As the worldwide Depression ended, the island was hit yet again by a monstrous hurricane. The 1940 hurricane did to the relatively new development at Edisto Beach almost what the 1893 storm had done to Edingsville. Most of the houses were destroyed completely, others blown off their pilings, and what few remained sustained extensive wind and water damage.

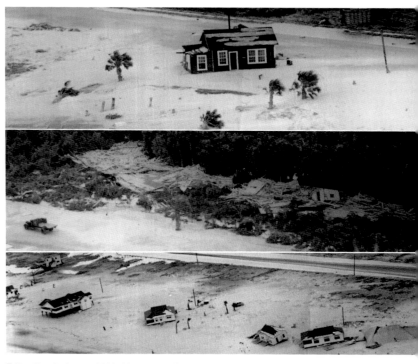

Edisto Beach, August 1940. Almost complete destruction of homes on the beach. Note the accumulation of lumber from destroyed homes in the middle picture. *Courtesy of Ellen Holmes Wright.*

In an eighty-year period, Edisto saw two wars (and another was right around the corner), one earthquake, four major hurricanes, the sinking of an inter-island ferry, the burning of a church and several homes, the end of the single crop which had supported the island for a century, and (to top it off) it shared with the world the Depression of 1929, the effects of which lasted until World War II.

The Modern Era

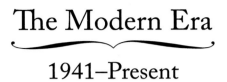

1941–Present

How one chooses to date the beginning of modern times at Edisto is totally dependent on one's point of view. Some might date it from the end of the long-staple cotton era, the First World War or the building of the Dawhoo Bridge (circa 1920); others from the development of the beach and the arrival of its first year-round residents (late 1920s); but I have chosen to begin with the 1940 hurricane.

It was in the aftermath of this great storm that the beach cottages of the '20s and '30s passed into oblivion and modern beach houses (many of them still standing) came into being. The island was electrified in the late '30s. During the '40s and '50s the number of visitors and residents increased significantly. The '60s and '70s brought burgeoning growth to the island, especially the beach, with new roads cut and paved, businesses opened and real estate expanded.

In 1970, Edisto Beach was incorporated as a town. In 1974, it was annexed into Colleton County out of Charleston County. Growth has continued with the building of a municipal complex including a town hall, fire department and EMS/police building. Restaurants and other businesses have been started and continue to thrive. Oristo, the development at the south end of the beach, was purchased by Fairfield Resort Communities and is now operated as Fairfield Ocean Ridge.

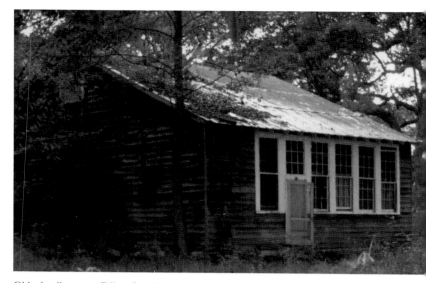

Old schoolhouse on Edisto. In 1880 there were four schools for Negroes on Edisto and Jehossee Islands. Until 1925, there were two seaside schools, black and white, and two borough schools, black and white. The Edisto Island Consolidated School opened in 1925. Other schools on the island included Whaley Industrial, Larimer Presbyterian and Central (site of the current Jane Edwards School). *Photograph by Britt Nickels, courtesy of the author.*

Although many homes were lost in the early decades of the twentieth century, homes began to be restored in the century's last three decades, and a commitment seemed to be made that all the structures of a historic nature would be saved. Property owners on Edisto also recognized that the island was worth preserving in other ways, too. Land-use plans were debated, attention was paid to maintaining Edisto's character as an agricultural community and ways were studied to preserve the properties of African Americans, many descended from Edisto plantation slaves.

Edisto, both Island and Beach, continue to grow and prosper. Fortunately, growth has been in keeping with the nature of Edisto as a

A view of the Pavilion on Edisto Beach from the Edisto Beach State Park. A pavilion has stood at this place for most of Edisto Beach's history. *Photograph by Susan Roberts.*

family beach. Up to now at least, development has avoided, for the most part, the gated communities of Hilton Head or the concrete, high-rise jungles of Myrtle Beach that have so predominated most of the eastern seaboard's coastal resorts.

May anyone who attempts to despoil Edisto with high-rises and other high-density developments suffer from corns, bunions, neuritis, neuralgia, the heartbreak of psoriasis and mother-in-law problems. May they also suffer bankruptcy before they cut down three-hundred-year-old oaks or fill in the marsh. May they decide to move back to wherever they came from before they build anything that can't be quickly and inexpensively torn down.

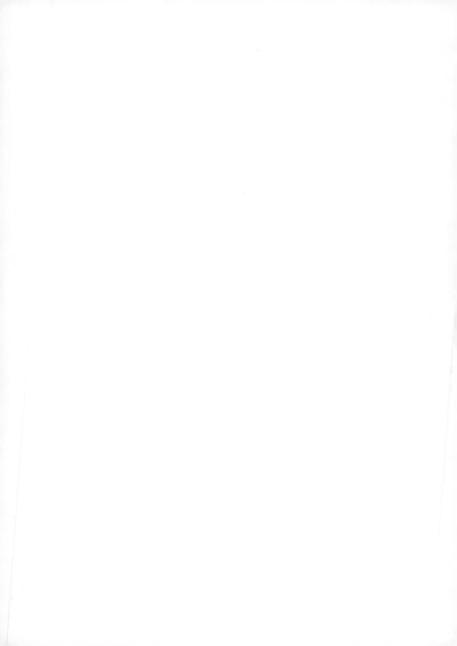

PART TWO

Leisure Pursuits

If you've got this book in your hand, I imagine that either you live here, are visiting here or are planning to live or visit here. Great! Edisto is a special place, and there are lots of ways to enjoy yourself. So let's get right to the heart of things: having a good time. In this section, I'll focus on Edisto-centric pursuits that have delighted visitors since time out of mind. I'll share with you what you need to know to enjoy the natural wonders of Edisto, especially fishing, shrimping, crabbing (and what to do with your catch once you get it), as well as beachcombing. For those of you looking for recipes, this is where you'll find them. So get your favorite beverage, get comfortable, and let's discover Edisto together!

Fishing

There is a relaxing sense of calmness imparted by fishing, a real adrenaline rush in catching fish. If you want to calmly while away an hour or two, then you really don't need to read this section; just take your bait and tackle, find a spot and have at it. If, on the other hand, you want to catch fish and eat well tonight, read on.

For simplicity's sake, I'll discuss fishing in four categories: offshore (deep-sea) fishing, inshore (bottom) fishing, river, creek or inlet fishing, and surf fishing. Note that the first and second types require a boat, and many people use one for the third as well. The fourth category, on the other hand, not only doesn't require a boat, you'd look pretty darned silly using one.

Definition of "boat": A hole in the water into which you pour every penny you can beg, borrow or steal.

Now if you have already invested in a boat, you've probably also dropped a bundle on radios, fish-finders, Color C-Lectors, rods and reels, natural and artificial baits and books galore on how and where to fish. You might as well skip this chapter, but not before I tell you that I'm free this Saturday and will share expenses.

If you don't have a boat or a good friend with one, you might like to try a charter. Although this is not a cost-effective way to put fish on the supper table, it is a tremendous amount of fun. Call the Marina for information.

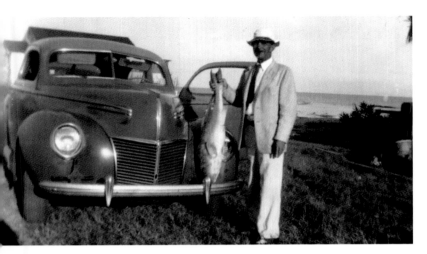

"Captain Mac" Holmes with a nice-sized channel bass. His sailing and boating skills were well known on the islands. He captained the Edisto Island sailboat *Minnehaha* to several victories in the Rockville Regatta. *Courtesy of Ellen Holmes Wright.*

OFFSHORE FISHING

Your captain will be the best advisor for deep-sea fishing. Just make sure you understand the costs and any rules of the boat in advance. Usually the captain provides the gear and the bait. Often he provides the food and beverage. He will decide where you fish and for how long. Forty miles is a long way out, so make sure you have everything you need before you shove off.

INSHORE FISHING

I love bottom fishing and that's one of the things I did a lot of as a kid at Edisto in the '50s and '60s. Granddaddy had a U.S. Navy surplus lifeboat he converted into a perfect inshore fishing boat and he was a master at visually triangulating some great fishing spots within sight of the beach. If you have kids, you really should consider inshore fishing because there is so much action

71

Edisto: A Guide to Life on the Island

for the children and a successful outing can last several hours rather than the eight, ten or twelve hours common to deep-sea fishing.

Two other advantages are that inshore fishing requires less skill and it can be done with a minimal expense in equipment. My mother was born and raised on Edisto and when we went fishing as a family, she continued to use a hand line as she had in her youth. Her hand line was nothing more than cord wrapped around a stout stick or a large oyster shell with a lead weight at the end and a hook. Mercy! She could catch more fish with that than any other two people in the boat who were using rods and reels. Speaking of tackle, just about anything will work, but I recommend a medium-length rod with a baitcasting reel. We were particularly fond of the reels made by Penn and there are many other companies making great reels with a wide range of prices. Pre-made leaders work very well; the most commonly used have two wire arms, each supporting short lines, at the end of which you attach a hook. A four-ounce pyramid sinker is tied to the bottom of the line. The two different distances these hooks will be from the bottom (four to six inches for the lower and eight to twelve inches for the upper) will help entice fish that feed at or near the bottom. The standard bait for bottom fishing is shrimp or squid. I've used sand fleas, minnows and any number of artificial lures, but I keep coming back to shrimp and squid. Either is better fresh than frozen.

If you're sophisticated city folk used to eating grouper, snapper, mahi mahi and the like, you are warned that you will catch none of these inshore. Be prepared instead for blackfish, whiting, croaker, trout and other fish not offered at your favorite bistro back home. If you want fun *and* supper, though, inshore fishing is going to fit the bill every time. Try it and you'll be as hooked as the fish.

RIVER, CREEK OR INLET FISHING

This kind of fishing is in some ways a hybrid of fresh- and saltwater fishing in terms of technique and equipment. In fact, many inlanders prefer it because, with a change in line and rigging, a medium-duty freshwater rod and reel can be effective. Tackle conversion requires no more than restringing with a heavier test monofilament and attaching any one of a number of appropriate rigs. I once caught a doormat-sized flounder on a cheap Zebco freshwater outfit with nothing more than the addition of a good flounder rig (metal leader, three-way swivel, a bank-type sinker and a long-shanked hook). Some river and creek anglers choose to use a standard bottom-fishing rig; I much prefer the above flounder rig or a fluke-spinner rig.

As with all fishing, arguments abound as to the best bait, and here things get even more complicated. For, in addition to those mentioned in the preceding section, artificial lures are often used to good advantage. I caught my big flounder on a purple stingray grub with a lead-head. Your local retailer will carry many of the lures that seem to work in the area, and the best advice I can give is to ask what's selling and buy several of each that are mentioned. More is better.

Again, tides are crucial to effective fishing, and the periods right after high and low tides seem to be best. As a rule, dead high and dead low (when the waters are still) is wasted time.

Locations for this type of fishing include Live Oak Landing, Steamboat Landing, Dawhoo Landing and Jeremy Inlet (the northernmost point of the beach adjacent to the State Park). Additionally, any place where Highway 174 crosses a creek is prime territory, but be advised that to fish from the bridges is not only hazardous but also illegal. Also, do not make the mistake of wandering onto private land—you will regret it if you do. Edistonians are real friendly until you trespass. You have been warned.

Edisto: A Guide to Life on the Island

Surf Fishing

This simple and usually gratifying pastime has a long and honorable history at Edisto Beach. And for good reason: all that is needed is the proper tackle, rigging and bait, and a little elementary knowledge of tides. What follows is a brief look at some of those components as I have experienced them. In all elements, however, budget and personal preference should be the most important considerations, and the advice and guidance of retailers on the island should always take precedence over what you read in this or any other guide. They deal with anglers daily, and are far more apt to know what's biting, where and on what. Most retailers are more than happy to share this knowledge with you if you are a customer (translation: buy something).

The ideal rod for surf fishing is either a saltwater bottom-fishing rod or a surf-fishing spinning rod. The former is usually five to seven feet, the latter, six to ten. In either case, they are usually in two pieces and the more traditional versions come with rubber-tipped cork handles. I prefer the shorter in calm seas and the longer when the surf is up. To be avoided are the stiff deep-sea trolling rods or the very limber freshwater rods.

More than rods, the variety of choices in reels these days is astounding (and often confusing). In general, what you are looking for is a light- to medium-duty saltwater spinning reel loaded with more than a hundred yards of high-quality eight-, ten- or twelve-pound test monofilament.

Most Old Salts prepare their own rigging depending on the species of fish targeted and surf conditions. For the novice, a commercially made rig is probably advisable, and in truth, is probably as effective. Start out with a standard surf rig with a double leader with three-way swivels, a four-ounce pyramid sinker and Eagle Claw hooks. An optional second rig to have in your armory would be a flounder rig.

Part Two: Leisure Pursuits

More than rod, reel or rig selection, the choice of bait seems to be the prime topic when anglers gather to tell their tales. While some successful surf fishers have used artificial lures, most don't and the debate centers on the benefits of shrimp over squid, mullet over mole crabs or live bait over frozen or fresh. I would like to give you a definitive answer to that debate, but I can't. The fact is that each will sometimes be successful and each will sometimes fail. Unless retailers or other fishers tell me otherwise, I start out with fresh or frozen shrimp.

Like bait, position on the beach is a relative thing. The best I can suggest here is that if the fish bite, stay; if they won't take any of your baits, move on. One mistake that many beginners make is to assume that the farther out they cast the bait, the better their chances of the big catch will be. This is almost always not the case. If you want deep-water fish, get a boat. Otherwise, stand on the beach (not in the water) and cast to a point at or just behind the breakers. There are two reasons for this: the current on the bottom just below the breakers is moving away from the beach and will hold the line taut, and this area of disturbance is a prime feeding area.

The last, and in many ways the most important, consideration for the angler is that of tides. The two best times are the beginning of the incoming tide (the hour or so after low tide) and the beginning of the outgoing tide (just after high tide). By far the better of these two is the incoming tide. One possible reason for this is that many burrowing creatures will come up to feed when the water first covers their area of beach and it is on these creatures that many local fish feed.

Now all you need is a hat, some sunscreen and an ice chest (holds your bait and beverages going in, your catch and litter going out, and makes for a great seat in between). So equipped, you are ready for the thrill of catching that big bass, sea trout, bluefish or drum. You also may catch

dogfish, catfish, stingrays or small sharks. Most folks just throw them back after bashing them in the head.

With these guidelines and several hours of your time, you should now be able to bring back something good for your supper. If not, don't talk about the one that got away. Just remember the old Gullah saying, "'most hook fish don' hep dry hominy." Translation: "the fish that you almost caught doesn't do a thing to help a plain plate of grits."

Crabbing

The Atlantic blue crab is a delicacy much sought after by the finest of landlocked restaurants and yet readily available to anyone on Edisto who has a sense of adventure and a spare hour or two. Equipment is simple and inexpensive: a long-handled net, some twine, a weight, bait (fish, chicken necks, turkey tails, etc.) and a large container for carrying the catch home.

Crabs abound in the tidal creeks on Edisto. Popular sites for crabbing include the two public landings (Steamboat and Live Oak) and almost anywhere that the creeks cross Highway 174. Crabbers should take care not to endanger themselves or others by parking too close to the highway. Also please remember that it is not only illegal, but also very unwise to wander onto private property.

The best time to crab is usually around low tide and as the tide begins to come back in. Some experts also report good results fifteen minutes before and after high tide. Since dead high and dead low varies with location, it is a good idea to get to your chosen spot early.

A time-tested method for catching the big ones is to tie a heavy weight (I like the smooth, tear-shaped lead sinker in the four-ounce weight) securely to the end of a stout cord. Attach a chicken neck to the cord a few inches above the sinker by wrapping the cord around the bait several times and then tying tightly.

Edisto: A Guide to Life on the Island

Cut the cord about twenty feet above the bait. Tie the end opposite the bait to a stick that is about ten inches long and one or two inches thick. Wrap the cord onto the stick in a figure of eight and you're ready to catch crabs!

Once you've chosen your crabbing spot (make sure the water is not farther below you than the handle of the net; it is best to be right on the water), let the sinker drop to the bottom. Keep the line slightly taut. When you feel a tugging at the line, slowly, **VERY SLOWLY**, bring the crab to just below the surface of the water.

It is best to have a second person work the net. The netter should dip the net slowly and quietly into the water about a foot from the crab (I try to do this so that the net is not between the sun and the crab). Once the net is fully immersed, the netter should rapidly sweep upward and over, catching the crab, the bait and the sinker.

Once the crab is in the net, remove the crab line. Hold the net over the basket (bucket, ice chest, etc.). Flip the net over 180 degrees and hope the crab will fall out. It usually won't; it'll be holding on for dear life. Shake the net until either the crab gives up or you become so frustrated that, against your better judgment, you decide to try to pry him loose. You did remember to bring Band-Aids, didn't you?

Several words of caution: crabs of less than five inches from point to point must be thrown back. Also needing to go back are the she-crabs if their spongy orange egg sac is protruding from the abdomen. This is the law.

How to Cook Crabs

Cooking crabs is utter simplicity itself, but, like so many other simple jobs, requires that you know some of the tricks. To cook crabs properly requires a large pot. Don't try to make do with the spaghetti pot or you'll be sorry. Large

pots made for steaming or boiling large quantities of food are available at most retail outlets on the island. Most are enameled dark blue with white specks and come with three pieces (pot, lid, steaming insert) and are reasonably priced.

After cleaning out the pot, remove the steamer insert, fill the pot half full (finally something that beach water is good for!!!), and place on the large eye of the stove, turned to high. Add a handful of salt and a handful of Old Bay seasoning. If measuring by the handful seems too imprecise, try a heaping tablespoon of each. Cover and wait for the water to come to a roaring boil.

Now comes the difficult part: getting the crabs into the pot. There are three basic methods: 1) Pour them out of the container where they happen to be spending their final minutes. This method usually fails. The entertainment value of having live crabs crawling all over your kitchen is grand enough that I thought I should list this method. 2) Use kitchen tongs and remove crabs one at a time and drop them into the pot. This method takes a little longer, but has the added benefit of allowing you to cull out any crabs that may have already gone on to their just reward. Dead crabs spoil quickly—don't use them. 3) Reach into the container with your bare hands and pull out the crabs one by one and drop them into the pot. It takes a good bit of practice to learn how, but it's guaranteed to impress friends and relatives.

Having somehow managed to get the crabs into the pot, you would be well advised to put the lid on. Crabs are about as happy at being there as you would be at an IRS audit. In fact, it's not a bad idea to put the lid on between crabs if using methods two or three above.

Now cut the temperature down enough to keep the pot from boiling over. Open a beer. Well, if you insist on drinking the beer, open a second beer; this one goes in the pot with the crabs. Cook for five or ten minutes, shaking the pot or stirring every few minutes. Remove the pot from the heat and let the pot sit for another five or ten minutes covered. Now dump the crabs into

the sink and let them cool down a bit. If you plan to eat them right away, go ahead and lay out some newspapers and grab the melted butter or cocktail sauce and prepare to dig in.

How to Crack Crabs

Remove the back from the crab first, and then remove the dead man. The dead man looks like feathery fingers just below the back. Break the body into two halves, left and right. Now break each body part a little at a time, uncovering little pockets of glistening white meat. Either eat directly out of the body, or remove with a cocktail fork. Since you get messy either way, I generally forego the fork; it seems to taste better without the fork anyway. I enjoy fantasizing on the common bond I share with the Indians who inhabited these parts hundreds of years ago. Of course if your fiancée's parents are meeting you for the first time, I guess a cocktail fork would be a nice thing to have on hand.

To get into the claws, you will need implements of destruction. Most common in these parts are (in order of preference): nutcrackers, channel lock pliers, regular pliers and hammers. The trick is to apply enough brute force to crack the shell without destroying the meat or splattering it over the walls, ceiling, furniture and yourself. In the presence of your fiancée's parents, save the claws for later and explain that for the perfect claw meat cocktail, the shells have to cool down first. Wait until they go to the store or for a walk on the beach and then have at it.

Shrimping

Recreational shrimping is a pursuit which, though always popular, has gained a huge following in the last ten years. This growth is due in great measure to the meteoric rise in the cost of shrimp and the simultaneous decrease in the cost of nets.

In my youth, a dollar's worth of shrimp bought from the docks would feed two people; now you'd be hard pressed to make a shrimp cocktail on what you could get for a buck. Nets, though, are now being made with nylon rather than cord, by Taiwanese or machines rather than Edistonians with names and faces, and the prices have plummeted. I remember looking at an old black man sitting on the dock and tying a new cast net (I must have been about eight at the time—he looked at least eighty) and asking him if what he was doing was hard. "No," he smiled with a toothless grin, "Ise jus ty de hole togeddah."

Well now, the first thing you'll need to decide if you're going to get a net is whether you want your holes tied together into a circle or a rectangle. The circle is called a cast net; it is thrown from boat or shore by one person, and is the most popular type of net used at Edisto. The rectangle is called a seine (pronounced "sane") and is pulled in the creeks by two people.

Cast nets come in a variety of sizes from six to fourteen feet in diameter (as well as some even smaller for children or beginners). They consist of monofilament netting, lead weights on the outside of the circle, a hole about

Edisto: A Guide to Life on the Island

two and a half inches in diameter in the center (called the "horn") and many strands of monofilament or cord attached to the outside of the net and extending underneath and up through the horn until they join a piece of stout line.

The cast net is thrown by holding the net by the horn until the weighted outside edge of the net dangles down without tangles, then holding the folded center portion with the left hand, one bit of the outside edge between the teeth, and another piece of the outside edge with the right hand. The other end of the cast net line should be attached to your arm, wrist, the boat or some immovable object near you. Keep your feet planted, swing the net and your upper torso to the left and then uncoil back to the right, releasing the net from your right hand and mouth almost simultaneously, and follow immediately thereafter by the top of the net from the left hand. Although this may sound about as easy as a Soviet gymnast's dismount at the Olympics, take heart, it's easier than it sounds. In fact, if you have ever successfully launched a Frisbee, you can throw a cast net, because the motion is about the same, just more pronounced.

The object of the cast is to get the net to fan completely out into a perfect circle before it hits the water and sinks. When this is done, anything under the net and larger than its holes will soon be yours. The instant that the weights hit the bottom (for all intents and purposes only a second or two after the weights hit the surface of the water) you should start hoisting in the line. As you do so, the outside of the net will come together, forming the net first into a globe and then into the shape of an upside-down three-dimensional valentine. To empty the net, hold it over the boat or a large receptacle (the ubiquitous five-gallon plastic bucket does not work well here—you need something wider), grab the horn with the left hand, let go of the cord with the right, and shake like there's no tomorrow. Non-keepers and other species that you are not planning to keep should immediately be thrown back.

Woody Kapp throws a cast net for shrimp in 1988. His wife, Cindy, and their children and dog stand ready to help with the catch. Practice makes perfect. *Photograph by Britt Nickels, courtesy of the author.*

Seining is a more strenuous activity and utilizes a larger, heavier and more expensive net. The seine is made up of a rectangular net (usually three to five feet high and twenty to fifty feet long) with flotation devices across the top edge of the net and lead weights across the bottom. At either end are poles used for holding the net upright and pulling it along the bottom and through the creek.

Method and location go hand in hand here. The best seining is done where the bottom of the creek is fairly flat and a section of sandy bottom is exposed at low tide so you'll have a "beach" to pull the net up onto. Once you've found a likely spot, unroll the net downstream from the area you plan to come out onto and pull the net upstream against the current as fast

as your weary legs will carry you. During the sweep, the bottom of the net should be dragging the bottom of the creek lightly, and the poles should be straight up and down or slightly pointed forward. As you approach the "beach," the person on the beach side should slow up and the person on the other side should begin to swing the net around to the upstream end of the beach. Ideally, the stronger, taller seiner will take this position, and will redouble his efforts at speed as soon as the partner has gotten his end of the net close to the water's edge.

How to Cook Shrimp

The proper technique for cooking fresh shrimp remains a fiercely debated subject, but I intend to put the argument to rest forever by sharing with you the definitive recipe for boiled shrimp.

First, the size of the pot you use should be two or more times larger than the amount of shrimp you plan to boil. The pot I use holds eight quarts and I find it to be an ideal size most of the time. Fill the pot two-thirds full with Edisto beach water. Now Edisto water may be a disaster for coffee, tea, drinking or bathing, but it does have its place in God's scheme of things: it's great for boiling seafood or making grits!

Bring the water to a boil. While you wait for the water to come to a roaring boil, add a little salt and some Old Bay seasoning. Tastes vary, but I use about one tablespoon of salt and two tablespoons of Old Bay in my eight-quart pot. A bag of crab boil (pickling spice, actually) may be added to the water in place of, or in addition to, the Old Bay.

Once the water is boiling furiously, dump in the shrimp, stir and look at your watch. The real secret to perfectly prepared shrimp is not overcooking them. Tiny little creek shrimp should cook for one minute, medium shrimp

for two minutes and jumbo shrimp for three minutes. Most shrimp that you will get down here are what I call medium. They are thirty to sixty count to the pound, or varying from the size of your little finger to the size of your thumb. If you buy or catch ungraded (mixed-size) shrimp, you should sort them before cooking. Throw the big ones in first, wait one minute and drop the mediums, wait another minute and drop the small ones. One minute after the small ones hit the water they will all be ready. I cannot overemphasize how important it is to avoid overcooking.

At the end of the cooking period, dump the pot's contents through a colander. Now dump the shrimp into a large pot or tub of iced water. If you plan to eat the shrimp hot, leave them in the iced water for just one minute, stirring several times. If you'll be eating the shrimp cold, leave them in the water for several minutes, adding more ice to the water as necessary to chill the shrimp down. Remove from the iced water, drain, put into large resealable plastic bags with as much air removed from the bag as possible, seal and refrigerate. (If you anticipate holding shrimp, raw or cooked, overnight, it is best to put the plastic bag in an appropriate sized bowl or pot and pack it with ice before you store it in the fridge.)

How to Peel Shrimp

Peeling shrimp is really easy once you get the hang of it. I hold the last section of tail between my left thumb and forefinger with the underside of the shrimp facing in toward me. I take my right thumb and put it on the underside about halfway up, then pry the side of the shell up, over and off. Then, grabbing the peeled half with my right thumb and forefinger, I gently pull as I squeeze the base of the tail with the left thumb and forefinger. The meat pops right out and down the hatch it goes. If you've never peeled

shrimp before, it may seem awkward at first, but hang in there. Practice makes perfect.

There are dozens of commercially prepared cocktail sauces on the market, but if you want to make your own, try the Shrimp Trawler Cocktail Sauce in the recipe section of this book. It tastes better if made in advance.

Beachcombing

Is there a person among us who can walk down the beach without once stooping over to pick up and examine a pretty or unusual shell? Has there ever been a child who did not instinctively become a shell collector? Is there even one beach house totally devoid of the ornamentation of conchs, sand dollars, starfish or coral? On all counts, I sincerely doubt it.

So what is this strange attraction we have for seashells? Perhaps it is the variety of shapes, textures and colors, or the fascination of holding in our hands the remains of that which once held life.

Whatever the cause for this interest, one of the best locations for collecting seashells, sharks' teeth and other fossils has always been Edisto Beach. Articles written back in the 1930s proclaimed Edisto as one of the premier beaches on the Atlantic seaboard for collectors. Although man-made structures (the groins and jetties) and the vagaries of nature (hurricanes, storms and erosion) have changed the topography of the ocean floor and the littoral beach, Edisto remains a choice spot for bones and teeth and for the former homes of the denizens of the sea.

The limited scope of this book precludes going into any depth about scientific classification into genus and species, but a brief primer on beachcombing treasures is in order for those who may be visiting the shore for the first time.

Most of the shells you will find are mollusks of the class Bivalvia (bivalves) or class Gastropoda (univalves). The bivalves include the two-shelled

creatures such as mussels, clams, oysters and scallops. With few exceptions, any cup-, bowl-, saucer-, or trough-like shell you find is going to be one half of a bivalve mollusk.

Univalves, by far the most prevalent class of mollusks on Edisto Beach, are the single-shelled animals such as conchs, whelks, snails and almost any other shell that is spiral-shaped.

Sharing the beach with the shells are fossilized remains of the hard parts (bone, shell, tooth) of animals that roamed the earth or swam the seas perhaps eight to eleven thousand years ago. Most often, they are black and glistening. They tend to be most prevalent on the beach after a winter storm out of the northeast. I am thankful to M.C. Thomas, author of *Fossil Vertebrates: Beach and Bank Collecting for Amateurs* and *Let's Find Fossils on the Beach*, for correcting misinformation I published in my first book regarding the age of fossils found on Edisto Beach. As she, with confirmation from Clayton E. Ray (then curator of the Department of Paleobiology at the National Museum of Natural History at the Smithsonian Institution), informed me, the fossil mammals known from Edisto Island are from the late Pleistocene. I stand corrected.

During my mother's youth on Edisto Beach in the 1920s and '30s (before television, and, until later in the 1930s, electricity!), there wasn't a lot to do during the winter after the summer folk had gone back to Walterboro, Aiken, Sumter, Orangeburg, Columbia or wherever they spent their non-Edisto months. My mother and her three sisters would often walk the beach collecting sharks' teeth and other fossils. Also during those winter months, they would identify the fossils with help from E. Burnham Chamberlain at the Charleston Museum, and from the National Museum of Natural History at the Smithsonian Institution. The fossils sent to the Smithsonian would come back with numbers in white ink on the pieces, and a numerical list with identifications. Some of this collection was

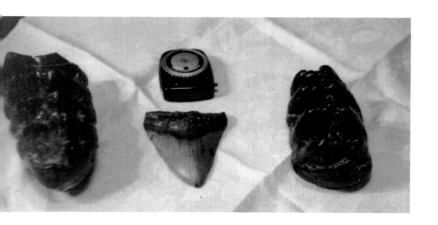

Shark's tooth flanked by mastodon teeth found on Edisto Beach in the 1930s. Many large and very fine specimens were collected by the Holmes family and cataloged by the Smithsonian Institution. *Courtesy of Ellen Holmes Wright.*

lost in the 1940 hurricane and some was later given to the Columbia Museum of Art and Science. The collection included the teeth of sharks, mastodons, capybara, saber-toothed tigers, camels, bison, tapirs, deer and many more. There were also a wide variety of bones (the largest being elephant and whale vertebrae), plates from sea turtles, giant armadillos and glyptodonts, and my favorite: the mouth plates of bony fish (such as the robin fish, parrotfish, puffer fish or their antecedents).

More information on identifying seashells and fossils can be found in field guides written for that purpose, but for the beginner the first question asked is not "what?" but "where?" And the answer is "almost everywhere, but not all the time." The ever-changing nature of the beach means that the great spot today may be nearly barren next week. This being the case, your best bet is to walk the beach, looking everywhere and pausing to explore whenever you come across a particularly fertile spot. Some guidelines might be helpful, though, and they are offered herewith: the "river beach," "South beach"

Edisto: A Guide to Life on the Island

or "back beach" starts at South Point (about the 3000 block of Palmetto Boulevard) and runs down to Big Bay Creek. Shells found there are apt to be small, delicate and often unbroken, but larger shells are frequently not to be found. I have not had much luck with sharks' teeth in that area, but have found some of my best fan coral there.

The stretch of beach from South Point north to the Pavilion is broken up by groins that, under many conditions, provide a collection point for shells and fossils. I find the area twenty feet or so on either side of the groins to be particularly productive.

The beach that runs beside the State Park (from the Pavilion north to Jeremy Inlet) is without groins and so the topography of the ocean bottom and beach tends to be flatter. Some of my most spectacular finds have been here, but alas, the competition here is also greater.

Perhaps the most prodigious section of beach is that of Botany Island, but you'll have to find someone to take you there by boat, as it cannot be reached by car or on foot. Check around to see if there is anyone doing charters (those who have done it in the past come and go). Botany Bay in winter after a big nor'easter is usually a treasure trove of fossils.

Does all of this sound interesting to you? If so, put down this book right now and hit the beach! There'll be time to read after the sun goes down. Happy hunting!

PART THREE

Recipes

I was amazed at how many people who read my first book were as enthralled with the recipes as anything else in the book. I've included all of the recipes from the first book plus quite a few new ones. Bon Appetit!

Fish

There is no one perfect way to cook fish. Fish vary. People's tastes vary. The one thing that can be said of all is not to overcook. If you are new to saltwater fishing, know that you'll have to head, gut, clean and scale just about everything you catch. Here are some ways of cooking fish that I like and hope you will, too.

Fried Fish (blackfish, whiting, croaker, trout or other small fin fish)

peanut or other oil
about ¼ cup flour or crackermeal per fish
⅛ teaspoon salt
pinch of pepper
brown paper grocery bag
1 or 2 fish per person, depending on size

Heat oil in a cast-iron skillet or a heavy pot over medium-high heat until a pinch of flour put into the oil immediately bubbles. Mix some flour or crackermeal with salt and pepper into the bag and shake once or twice. Put a fish into the bag, shake several times, then remove the fish and place it carefully into the hot oil. Dust another fish and then another until you have placed as many fish into the oil as can be without their touching each other. When they float, they are done. Remove carefully from the oil and place on a paper towel on a warm plate and put into the oven to stay warm. Continue until all fish have been cooked. You will want to have already prepared anything else you are having with the meal so cooking the fish can be the last thing you do. Remember that these fish are on the bone. To get the meat off the bone, place the edge of your fork on the side of the fish up near the dorsal (back) fin. Press down gently and pull down from the fin. The fish will flake off of the bone.

Grilled Fish (grouper, snapper, tuna, mahi, mackerel or other larger fin fish)

Worcestershire sauce
low-sodium soy sauce
$\frac{1}{2}$ teaspoon sugar per person (optional)
lemon or lime (optional, 1 of each for every two people), half
 of each sliced, the other half squeezed
8 ounces fish per person, skinned and filleted (each about the
 size of your hand)
cooking oil or melted butter
salt and/or pepper

Light your grill. Mix Worcestershire, soy sauce, sugar and
lemon or lime juice. Marinate the fish in the sauce for an hour,
or right before you cook, depending on how pronounced you
want the marinade flavor to be. When the grill is hot, rub a
small amount of oil or melted butter onto the grill. Remove
the fish from the marinade and pat dry. Rub both sides of the
fish with oil or butter and sprinkle with salt and/or pepper, if
desired. If you have marinated with regular soy, don't add any
salt at this stage. Place the fish onto the grill. Allow to cook for
between 3 to 5 minutes, depending on the thickness of the fish
(the fish should appear done halfway up the side of the piece of
fish). Turn the fish carefully and complete the cooking, usually

another 3 to 5 minutes. The fish is done when a fork pressed on the top no longer makes an impression. Remove from the grill and top with lemon or lime slices, if desired.

SHRIMP

PB's Shrimp and Grits (Shrimp Hominy)
With thanks to Philip Bardin of The Old Post Office Restaurant, Edisto.

This splendid supper dish is of humble beginnings. Everybody in the South had grits, and those blessed to live near the ocean or salty tidal creeks had shrimp in abundance. When times were lean, a gracious serving of grits topped with fresh-caught shrimp moistened with some "shrimp gravy" and a few slices of vine-ripened tomatoes on the side made for a mighty good, filling dinner at midday or supper in the evening.

10 strips bacon, chopped
2 tablespoons onion, finely minced
1 pound shrimp (or more, if the good Lord provides)
 (preferably creek shrimp), peeled
⅛ teaspoon nutmeg
 (**OR**) 1 tablespoon dried basil leaves
dash black pepper
hominy
2 tablespoons cream (optional)
grated cheddar cheese (optional)

Edisto: A Guide to Life on the Island

Put bacon pieces into skillet and cook over medium-high heat until bacon is done (when it "foams"). Remove bacon and place on paper towel with slotted spoon. Add onion to bacon drippings and cook until soft. Add shrimp and sauté for 1-2 minutes, or until shrimp are uniformly pink. Add seasonings and bacon. You may drain and serve over hominy, or you may prefer to add undrained contents to the pot of hominy and mix well before heaping onto the plate. For an extra special treat, add a couple of tablespoons of cream and some grated cheddar cheese to the hominy at the same time you add the shrimp mixture. Let stand, covered, for about 5 minutes before serving. This is a real delight whether served at breakfast, brunch or supper.

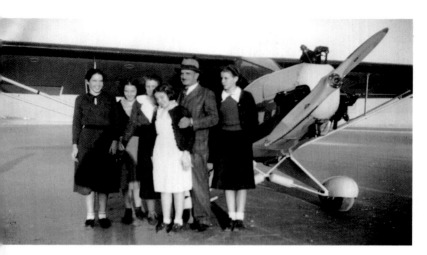

Mac and Sarah Holmes and their daughters pose on the beach by an airplane owned by T. Kenneth Ellis circa 1938. Ellis took off and landed on the wide expanse of beach. This day, he took each of the Holmes girls up in the plane in turn. Sarah Holmes (third from right), "Sarah B" to her husband, was known far and wide for her culinary skills. *Courtesy of Ellen Holmes Wright.*

Shrimp Paté (Shrimp Paste)
With thanks to Philip Bardin of The Old Post Office Restaurant, Edisto.

A great appetizer!

1 pound shrimp, peeled
¼ cup onions, minced
½ stick butter
1 cup spicy tomato sauce (see recipe in Sauces section below)

$\frac{1}{4}$ teaspoon balsamic vinegar
1 pound cream cheese, softened

Sauté shrimp and onions in butter for 4 minutes. Add tomato sauce and vinegar and simmer over low heat for 5 minutes. Put all ingredients into food processor and puree at high speed with metal blade. Refrigerate. Serve with crackers.

Sarah B's Shrimp Salad

As a child I spent precious hours with my grandparents at Edisto. Granny (Sarah B) could make something special to eat out of the humblest ingredients. Give her special ingredients, and what she turned out would make a grown man cry tears of joy. We spent a lot of time down in the creeks shrimping with our first cousins, our second cousins, our third cousins and those unrelated friends who were, nonetheless, called "cousin." One of our favorite middle-of-the-day meals during the summer was the shrimp salad made by Sarah B.

1 ½ pounds boiled shrimp, chilled, coarsely chopped (see the
 section on cooking shrimp in chapter ten, Shrimping)
¾ cup Durkees Sauce
¾ cup mayonnaise
2 or 3 stalks celery, diced
4 eggs, hard boiled, peeled, coarsely chopped
salt and pepper to taste

Mix all and refrigerate until ready to serve over the lettuce of your choice. Serves 8, more or less, depending on how seriously you love shrimp. If you prepare the shrimp salad in the morning, be prepared to fight off nibblers.

Fried Shrimp

Is there anything that brings to mind being at the beach more than freshly caught fried shrimp? On Edisto the tradition is for very lightly flour-dusted (or cracker meal-dusted) shrimp. All that is needed is a little something to sear the outside of the shrimp when it fries. No battered or heavily breaded shrimp here; we go for the unadulterated taste of the shrimp itself. If you have an electric deep fat fryer, getting the shrimp prepared perfectly is a breeze. If you don't, getting the oil to the proper temperature in a skillet or heavy pot can be a bit tricky unless you have an instant-read thermometer (365 degrees is perfect). If you don't have one, don't worry. After the oil is hot, drop a tiny amount of flour into the oil. If it immediately bubbles furiously, the oil is ready. If not, wait a little longer or cut up the heat. When you think the oil is hot enough, try frying one shrimp. It, too, should cause the oil to bubble furiously.

peanut or other cooking oil
about ½ cup flour
¼ teaspoon salt
pinch of pepper
brown paper grocery bag
½ pound shrimp per person (for 26/30ct shrimp, ½ pound = about 14 shrimp)

By whatever method you have available, bring your oil up to temperature. Put ¼ cup flour, salt and pepper into bag. Close the bag and shake it a couple of times to get the seasonings mixed and to dust the inside of the bag. Add 6 or 8 shrimp into the bag, seal and shake. Remove the shrimp and drop them one after the other (not at the same time) into the oil. While that batch is cooking, you can dust the next batch, adding more flour and seasonings as needed. When the shrimp is a light golden brown and/or it floats to the top of the oil, it is ready. Remove with a slotted spoon and place onto a warm plate in the oven until all shrimp have been cooked. As with any other cooking method, don't overcook.

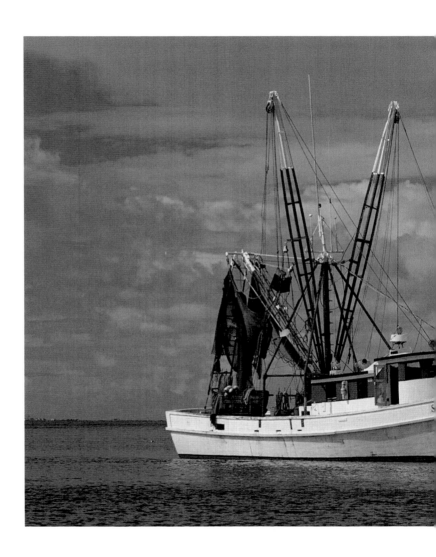

Shrimp trawler off Edisto. In season, fresh shrimp, caught right off boats like this one, are abundantly available. The boats can be seen heading north in the mornings and back south in the afternoons. *Photograph by Susan Roberts.*

CRAB

Some days you may harvest a bushel basket of crabs; other days you'll think the crabs have all packed up and moved to a more expensive neighborhood. The cost of bought crab would certainly cause one to think that. I do believe that Edisto has been over-crabbed commercially, but there are still those bushel basket days that keep us all coming back to the creeks. See how to cook and crack crabs in the crab chapter of the book.

Granny's Deviled Crab in Scallop Shells

¼ cup celery, finely chopped
3 tablespoons butter
4 cups crab, cooked and twice-picked
1 cup bread crumbs (or less)
1 teaspoon salt
¼ teaspoon pepper
⅛ teaspoon nutmeg
¼ teaspoon Tabasco
½ cup mayonnaise

Sauté celery in butter. Add all other ingredients and mix well. Spoon into cleaned scallop shells and bake at 350 degrees for 30 minutes.

Crab Salad

(Made just like Sarah B's Shrimp Salad.)

1 ½ pounds crab, cooked and twice-picked
¾ cup Durkees Sauce
¾ cup mayonnaise
2 or 3 stalks celery, diced
4 eggs, hard boiled, peeled, coarsely chopped
salt and pepper to taste

Mix all and refrigerate until ready to serve over the lettuce of your choice. It helps if you have a house full of children to help pick the crab, but always pick through it a second time to find those annoying little bits of shell. Serves 8, more or less.

She-Crab Soup

Ubiquitous in the Lowcountry, there are as many recipes as there are cooks. I like mine; you may, too. But first, a little crab knowledge will go a long way, so bear with me. Jimmies are male crabs. Sooks are female crabs. Jimmies have T-shaped abdomens. Sooks have triangular abdomens. Law requires that any crab that measures less than 5 inches from tip to tip must be thrown back. If the crab you catch is a sook with a bright orange spongy mass exuding from the abdomen, you must throw her back. The spongy mass is the roe (eggs). Sooks do have roe for a time before the abdominal plate opens to expose the spongy roe. It is the crab roe from the sooks that give she-crab soup its distinctive rich flavor. If you have enough large sooks to make your soup, great; otherwise, use jimmies and sooks.

1 tablespoon butter
1 tablespoon flour
1 quart of half and half
1 small onion, peeled and left whole
pinch of nutmeg
pinch of salt

 pinch of fresh ground black, white, pink or Tellicherry
 peppercorns
 12 crabs, sooks preferred, cooked as directed in the crab
 chapter. Should yield about 1 pound of meat. If using all
 sooks, you may yield about a cup and a half of roe.
 1 pint heavy cream, more or less as needed
 sherry (optional)

Make a blonde roux by cooking butter and flour in a skillet for 5 minutes, or until the floury flavor has gone away. Do not overcook. Put the roux into a custard cup or other small container and place in refrigerator or freezer to cool. In a medium pot, pour the half and half and add the whole onion. Over medium heat, bring liquid to a slight simmer. Cut burner down as necessary to keep the half and half at a slow simmer for 15 minutes. Add the roux to the hot liquid and stir constantly until slightly thickened. Remove onion, add ground seasonings and continue simmering for 5 more minutes, stirring frequently. Fold the crabmeat and roe into the liquid gently. Add cream. If additional liquid is needed, add more cream. Just as the soup returns to a simmer, remove from the stove and serve immediately, if possible. Traditionally, a wee dram of sherry is poured onto the top of the soup after each cup or bowl has been placed in front of the guest.

Oysters

Whether you harvest your own oysters (ever more difficult to do) or purchase them, you will love the slightly salty version that grows in the creeks around Edisto. Far more flavorful than the singles from the Gulf Coast, oysters here give up their flavor with a bit more work. In the fall and winter on Edisto, oyster roasts are the event of choice when having a party. At its most basic, an oyster roast requires oysters, a fire, a piece of metal, a water source, oyster knives, oyster gloves or towels and a place to put the oysters after they are cooked. The hot sauce is optional. The cocktail sauce is optional. The saltine crackers are optional. It's all about the oysters. And about friends.

Roasted Oysters (Steamed Oysters)

Set a fire and stoke it. Place an iron or steel sheet over the fire. Dump the oysters onto the metal sheet. Cover the oysters with the burlap sack the oysters came in, soaked in water. The water turns to steam and the oysters begin to crack open. When just open, the sack is removed and the oysters are shoveled onto a table (most often a four-by-eight sheet of plywood with a hole cut at either end, resting on two empty fifty-five-gallon oil drums centered beneath the holes). Once the oysters hit the table, folks descend on them, popping the shell the rest of the way open and extricating the hot, steaming delicacy that has been enjoyed on Edisto for literally thousands of years. Some put a drop or two of hot sauce on the oyster. Others use cocktail sauce. Some put the oyster on a cracker before eating it. Yet others let the oyster slide out of the shell and into their mouths. Some like their oysters firm and more done. Others like them just warm and gooey. When an oyster is eaten, the empty shells are pushed through the holes and into the barrels (the shells are later added to existing oyster beds to help propagate the species).

Oyster Stew

1 teaspoon butter
1 stalk celery, sliced thin or minced
1 tablespoon onion, finely minced
1 can evaporated milk (or 1 cup half and half)
1 pint oysters, shucked (reserve liquor, or juice)
salt and pepper to taste

Put butter into saucepan over medium heat until hot. Add celery and onions and cook until transparent. Add milk and oyster liquor to the pan and bring the contents to a simmer. For a thicker, richer broth, you can substitute heavy cream in place of the evaporated milk or half and half. Allow the mixture to cook for 5 minutes, then add oysters. Cook for another minute or two, or until the oysters are the desired degree of doneness. Traditionally served with saltine crackers but is really great with fresh bread to "sop up the last drop."

Oyster Pie

For many Edistonians, oyster pie is a traditional Christmas Eve supper dish. The best I ever had was prepared and served at the home of a Whaley. Seeing as how Whaleys have been on Edisto for hundreds of years, I shouldn't have been surprised that they would have mastered the recipe. I couldn't talk them out of it, but this one is pretty good. You don't have to wait until Christmas to try it.

4 tablespoons butter
4 tablespoons flour
4 pints oysters, shucked (reserve liquor)
1 quart heavy cream
⅛ teaspoon ground nutmeg
1 or 2 drops of hot sauce
1½ teaspoons Worcestershire sauce
2 sleeves of saltine crackers (half a box)
salt and pepper to taste
unsalted butter

In a small saucepan over medium heat, make a roux by melting the butter and whisking in the flour. Cook about 5 minutes or until pasty flour flavor is gone. Set this aside to cool. Put the oysters, with liquor, into a medium-sized pot over medium heat.

Cook until the oysters just begin to firm up. Remove the oysters from the liquor and set aside. Add the cream, nutmeg, hot sauce and Worcestershire to the pot. Bring this liquid to a simmer and cook until the quantity is reduced by half. Whisk in reserved roux until the liquid just begins to thicken. Crumble up the saltines and add to the pot. Stir gently until the liquid is absorbed. Taste and season to your liking with salt and pepper. Put half of the mixture into a glass baking dish, cover with oysters, spoon the rest of the mixture on top of the oysters, then top with slices of unsalted or lightly salted butter. Put into a 350-degree oven and bake for 10 minutes. Do not overcook. The dish may be refrigerated overnight and baked the next day.

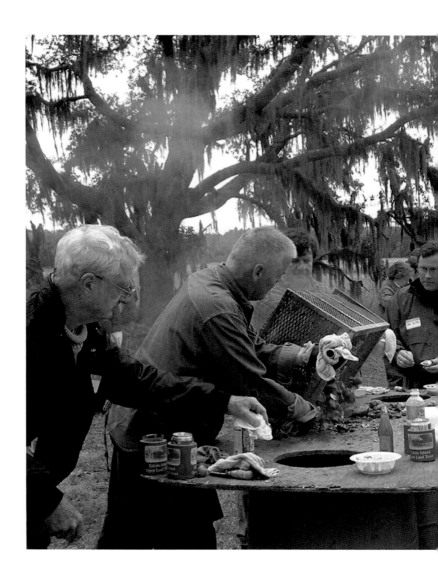

An Edisto oyster roast, hosted
by the Edisto Island Open Land
Trust. Indians, plantation owners
and current Edisto lovers have all
enjoyed the succulent oysters and
the fellowship of oyster roasts.
Photograph by Susan Roberts.

Sauces for Seafood

Easy Remoulade

1 tablespoon fresh parsley, rinsed, minced, rinsed again and
squeezed dry

6 tablespoons mayonnaise

2 tablespoons Dijon mustard

1 hard-boiled egg, chopped

1 teaspoon dried tarragon leaves

½ teaspoon salt (optional)

½ teaspoon white pepper (or to taste)

1 teaspoon capers, chopped

Okay, I'm a little obsessive about parsley. Like any other agricultural product, it should be washed. Shake off the water, then pick out and discard the stems. Put the tops on a cutting board and mince until fine, but not a paste. Put the minced parsley into the center of a kitchen towel and then hold the towel so that the parsley is in a ball. Hold under the faucet, then squeeze out the (now green) water. Repeat several times until the water no longer runs green. Take the parsley out of the towel and place in a small uncovered dish (a custard cup is what I use) and set aside. Okay, now you're ready to use your parsley for flavor, color or garnish. Mix all ingredients and refrigerate for six hours before using. Excellent with all cold seafoods, as a binder for shellfish salads and in lieu of tartar sauce with fried seafoods.

Landlubbers' Cocktail Sauce

7 ounces (half a bottle) ketchup
1 teaspoon Worcestershire sauce
Tabasco sauce to taste (4 drops = mild)
1 teaspoon lemon juice

Mix all ingredients. May be used immediately, but improves after several hours of refrigeration. Good for raw oysters or clams, steamed or boiled shellfish and all fried seafood.

Shrimp Trawler Cocktail Sauce

There are dozens of commercially prepared cocktail sauces on the market, but if you want to make your own, try Captain Whit's Shrimp Trawler Cocktail Sauce. Tastes better if made in advance and refrigerated.

1 bottle chili sauce
2 tablespoons pure prepared horseradish
2 teaspoons Worcestershire sauce
¼ teaspoon Tabasco (or more!)
1 teaspoon fresh squeezed lemon juice
dash of celery salt

Mix all ingredients. Have iced tea, cold beer or plenty of water on hand to put out the fire. Absolutely superb with oysters (raw, roasted, steamed or fried), boiled shrimp, raw or steamed clams, shark (baked or fried), grilled mackerel, swordfish or tuna and just about any fried seafood.

White Cocktail Sauce

6 tablespoons mayonnaise
2 tablespoons pure prepared horseradish
1 teaspoon lemon juice
2 teaspoons Worcestershire sauce
Tabasco to taste (4–10 drops)

Mix all ingredients. Best if refrigerated for at least 3 hours. Excellent dip for fried mushrooms or zucchini and fried seafoods.

Hollandaise I (Blender Hollandaise)

3 egg yolks*
2 tablespoons lemon juice
½ teaspoon salt
pinch red or cayenne pepper
1 stick butter, melted

Put first four ingredients into blender (or food processor with steel blade) and cover. Turn blender on low, remove cover and slowly pour hot butter in steady stream until all butter is used (for food processor, the cover stays on and the butter is poured through the feeder tube). Makes about ¾ cup. Good with any broiled or baked fish.

*For safety's sake, use only pasteurized eggs for this recipe.

Hollandaise II

$^1\!/_2$ cup boiling water
2 egg yolks
$^1\!/_2$ cup melted butter
1 tablespoon lemon juice
$^1\!/_2$ teaspoon salt
pinch red or cayenne pepper

Put a small amount of water into double boiler and bring to a boil. In top of double boiler, beat yolks with wire whip until lemon-colored. Slowly dribble in melted butter while stirring vigorously with whisk. Add boiling water, stirring constantly until sauce thickens. Remove from heat and stir in lemon juice, salt and pepper. Makes about 3□4 cup. Good with any broiled or baked fish.

Sauce Moutarde I (Hollandaise-based)

¾ cup Hollandaise Sauce I
½ teaspoon Dijon mustard

Make Hollandaise. Add mustard and stir with wire whisk until blended thoroughly. This sauce works equally well for white-fleshed fish (flounder, grouper, snapper), darker fish (mackerel, salmon, bluefish, tuna) and dense medium-colored fish (swordfish, dolphin, pompano).

Sauce Moutarde II (Cream-reduction)

½ pint heavy cream
1 teaspoon Dijon mustard
pinch salt
pinch white pepper

Put cream into sauté pan over high heat and reduce by half. Add mustard, salt and pepper, stir well and reduce heat to low. Simmer for 5 minutes. See Sauce Moutarde I (above) for serving recommendations.

Mustard Caper Sauce

Sauce Moutarde I or II
1½–2 teaspoons capers, chopped

After making Moutarde Sauce, add capers. This is the sauce of
choice for the darker-fleshed fish listed in Sauce Moutarde I.

Spicy Tomato Sauce

2 cans whole tomatoes
1 cup water
1 teaspoon instant chicken bouillon granules (or 1 bouillon cube)
1 tablespoon Worcestershire sauce
1 stick butter
1 medium onion, finely diced
1 medium bell pepper, finely diced
1 stalk celery, finely diced
1 fresh jalapeño pepper, finely diced (or substitute ½ teaspoon Tabasco sauce at the end of the cooking process)
1 small can tomato sauce
salt and pepper

Put first four ingredients into large saucepot over high heat. Meanwhile, melt butter in sauté pan over medium-high heat and sauté onions, peppers and celery until soft, but not brown. Drain vegetables and add to tomatoes along with the can of tomato sauce. Add Tabasco, if not using jalapeños. Reduce heat and simmer until thick (about 20 minutes, depending on size of pot). Add salt and pepper to taste. Can be used as is for broiled or baked fish or served as a marinara for clams; with the addition of garlic, mushrooms and ground beef it makes a good spaghetti sauce. See also: Creole Sauce.

Creole Sauce

½ cup butter
½ cup plain (all-purpose) flour
Spicy Tomato Sauce Recipe (see above)

Preheat oven to 350 degrees. Heat butter in a cast-iron skillet over medium heat. When butter begins to sizzle, add flour and stir with wire whisk until blended. Cook for 5 minutes, stirring frequently, until you have a thickening paste (blonde roux). I prefer the nuttier flavor of a golden or brown roux. For a darker roux, place the skillet into preheated oven and cook until golden brown (about 6 minutes). When roux is brown, remove from skillet to bowl and place in refrigerator or freezer to chill. When roux is cool but not yet hard, add to hot tomato sauce, a little at a time, stirring vigorously with wire whisk. The key to thickening the roux is to make sure the thickener and the liquid are opposite temperatures (cold roux and hot sauce or hot roux and cold sauce). This sauce is excellent over baked, grilled or blackened tuna, mahi, salmon, mackerel or swordfish. For Shrimp Creole, add raw peeled shrimp to hot sauce for 8 minutes and serve.

OTHER FAVORITES FROM THE ISLAND

Pompion Chips (Pumpkin Chips)

1 firm, medium-sized dry pumpkin
1 cup sugar to each 2 cups of pumpkin chips
1 dozen lemons, juiced, reserve rind

Peel pumpkin and cut into thin pieces, $\frac{1}{2}$-inch square. Add sugar and lemon juice. Let stand overnight. The next day, pour the chips and liquid into a heavy pot and boil the chips until they are transparent. Remove the chips from the pot and boil the syrup until it thickens a little. Cut the lemon rind into strips and boil them in another pot until they are soft. Add the pumpkin chips and the lemon rind strips into the thickened syrup and bring to a boil. Once it has come to a boil it can be placed in jars and sealed. Yields 6–8 pints.

Chocolate Fudge

Thanks to Wallace and Amy Trowell. Amy was the longtime librarian of the Edisto Island branch of the Charleston County Library.

A recipe from Mr. Ray Cole, chemist at Hercules, Inc., Research Center, Wilmington, Delaware, 1936. Ray Cole liked to keep this recipe a secret. However, Wallace Trowell had the laboratory right next to Ray's and Ray rather reluctantly gave Wallace the recipe. (Note that the method refers to "flames." For those who don't have gas, I am including my conversion to settings for electric ranges. I am also retaining the brand names as the recipe was written.)

2½ squares (2½ ounces) chocolate
2 tablespoons Caro syrup
2 cups sugar
¾ cup Pet milk (canned evaporated milk)
2 tablespoons butter
2 heaping teaspoons Marshmallow Whip or Fluff
1 teaspoon vanilla extract
1 cup chopped nuts

Over a small flame, (low to medium-low) melt chocolate in an aluminum saucepan. Add Caro syrup, sugar and milk. Put over hot flame (medium-high) and stir constantly until mixture begins to boil. Then diminish flame until boiling is regular and slow (medium-low), continuing to stir constantly and allowing to boil slowly for 9 minutes. (Time it exactly.) Remove from flame and

add lump of butter the size of a walnut. With a rotary beater, beat above mixture. Add to mixture Marshmallow Whip or Fluff. After beating 2 or 3 minutes, add vanilla and nuts. Pour in pan, let cool then cut into pieces.

Edisto: A Guide to Life on the Island

Chess Pie (Lemon Chess Pie)

As the tale goes, the husband of the woman who first made this pie asked his wife what it was. "It's jess pie," she said (it's just pie). He thought she said "chess" pie, and that's what it's been ever since. Others think it was originally "chest" pie because it would last well in a pie chest (pie safe). Whatever the origin of the name, it is a very quick and easy pie and is a perfect ending to a rich seafood meal.

For the crust:
1¼ cups flour
½ teaspoon salt
⅓ cup shortening
3–4 tablespoons cold water

In a bowl, mix flour and salt together. With a pastry cutter (or 2 knives), cut in shortening until the flour and shortening form balls the size of peas. Sprinkle in cold water and toss gently, as little as possible, until dough forms a ball. Press onto floured board and roll out. Gently place in pie pan, cut away excess, crimp edges and put into refrigerator until ready to bake.

For the filling:
½ pound butter, melted
1½ cups sugar
4 eggs, beaten
3 lemons, juiced, and rind, grated

Preheat oven to 425 degrees. Mix all the ingredients together. Pour into pastry pie shell, place onto sheet pan and bake for 13 minutes or until lightly browned.

PART FOUR

Nature

When asked why Edisto is such a special place for me, my answer is that I continue to be awed every day at the majesty and splendor of God's creation here: the ocean's power and serenity; the cold knife thrust of a January nor'easter on the beach and the flittering of butterflies on a warm September afternoon; the sweet stench of death and birth from the pluff mud of the marsh; the graceful awkwardness of the great blue heron lifting off in flight and the streamlined grace of a pair of bottlenose dolphins arcing in and out of the waters of a creek; the timid beauty of a deer as it stares me down on a dirt road and the lethal swoops of a broad-winged hawk hunting supper over the fields.

These are but the hundredth part of the hundredth part of the profound glory of nature that I find so compelling on Edisto. To identify and catalogue what our eyes behold would take several lifetimes. But it isn't necessary; all we need do is open all our senses, take it in and give thanks for what our gracious God has given us.

But that appreciation can be enhanced by some degree of knowledge and understanding of nature and its phenomena, so this book offers a brief guide to some of the things you are likely to encounter on this sea island.

Sea, Beach and Marsh

The Sea

The movement of waves and the relentless power of the breakers is probably one of the first really strong impressions most people, child or adult, get when seeing the ocean for the first time.

What causes the moving swells we call waves is the friction of the wind against the surface of the water. This friction causes a circular movement of water molecules on and just below the surface, which causes the water to rise and fall. Pressure from the windward side of such a swell, and lowered pressure on the leeward side, causes the swell (although not the water itself) to move forward. This concept is more easily understood if you watch a pelican bob on the waves as he floats just offshore. The wave will tilt him one way, lift him up, tilt him the other way and then let him down, but he will be in the same place after the wave has passed.

Understanding waves is essential to comprehending why waves "break" when they get close to shore. Imagine, if you will, an upright bicycle tire, without a rim or spokes, spinning toward the shore. This is analogous to the movement of water molecules at and just below the surface. Now when the bottom of the tire first hits bottom as the water gets shallower, its circular movement will be slowed. But the opposite side of the tire will keep on moving due to momentum and the continued pressure of the

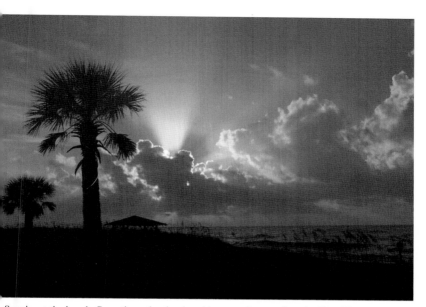

Sunrise at the beach. Sometimes the simplest things are the most breathtaking. *Photograph by Jack Anthony.*

wind. The result would be that the top of the tire would move forward faster than the bottom, the tire would lose its round shape, and the top would bend forward and over the bottom until gravity pulled it down and the tire collapsed. This is essentially what happens to waves as they hit the shallows.

The other fascinating dynamic of the ocean is that of tides. The sun and moon both exert a pull on the earth that most readily affects the water of the oceans. The greater pull is produced by the moon, due to its position nearly four hundred times closer to us than the sun. The result is that the oceans bulge out toward the moon, and to a much lesser degree, toward the sun. Landmasses adjacent to the bulged areas of ocean experience the higher levels we call high tide. As the earth rotates "under" the bulge, new

areas come into their stage of high tide, and areas that were there move out of the bulge and into a position of less pull where they experience low tide.

Because of the earth's rotation and the movement of the moon around the planet, we encounter a high tide every twelve hours and twenty-five minutes; low tides six hours and twelve and a half minutes in between highs. Additionally, when the sun and moon are on the same side of the planet (at new moon) or on opposite sides (full moon) their combined pull makes for higher high tides and lower low tides. The greater disparity between the extremes has caused the resulting tides to be referred to as spring tides.

When the sun and moon are at right angles to the earth (first and last quarter moons), their pulls serve to counteract one another, causing less of a difference between high and low tide levels. These are called the neap tides (from the Middle English, meaning "scanty"). There are two spring and two neap tides each month.

I was eating breakfast at the Pavilion one morning. The spring high tide was made even higher by a strong northeast wind, and as my four-and-a-half-year-old friend and I looked out of the picture window she asked, "Who made the ocean?" "God," I answered, almost without thinking. "Well it looks like God forgot and left the hose running," she said in quiet awe. I realized as I hugged her and laughed that I couldn't have described it any better.

THE BEACH

The beach at Edisto is perceived by many as an expanse of white sand, packed hard at water's edge, loose and hot on the high beach, and punctuated by seashells and sunbathers—a picture postcard of summer days at leisure. While it is this, it is a whole lot more.

The beach is a living and changing thing. It is moved by tides, currents, hurricanes and man; it serves as a home for plants and creatures too numerous to name; and it takes on entirely different faces at night and in the months when the movement of people on the beach drops from a flood to a trickle.

The sand on our beach is made up of crushed quartz, broken and ground-up seashells and detritus (waste and disintegrated marine plant and animal matter). Together, under the pounding breakers, they form the beach sand we love to walk on and play in, but find so difficult to fully get rid of once we come indoors. Do you think it would help if we put up a sign over the doors to our beach homes that reads: "No Silicon Dioxide, Calcium Carbonate or Detritus Allowed on These Premises"? Oh well. It was just a thought.

The sand that finds its way into our homes is, in fact, home to many of the curious creatures we derive so much pleasure watching. In the hard-packed sand of the low beach reside clams, lugworms, mole crabs, ghost crabs and many other species. They provide food for dozens of types of shore birds and, when the tide is up, additional dozens of marine animals. Digging at shore's edge by day or walking with a flashlight at night is an activity that shouldn't be missed.

At the uppermost edge of the high beach we find the dunes adorned with sea oats and other grasses. It is here that nature provides protection against erosion, and here where man has been most guilty of poor stewardship of the coasts.

The dynamic involved prior to man's arrival was that sand, blown by onshore breezes, caught by dune grasses and dropped to the base of the plants, renourished that which was lost due to erosion. Although the dunes moved backward or forward over time, there was some degree of stability generated by this system.

Edisto: A Guide to Life on the Island

Man's arrival on the scene has altered this dynamic. In its least damaging aspect, our mere presence on the dunes has weakened those structures and made them less efficient in catching windblown sand. Cutting or otherwise destroying dune grasses has exacerbated this problem even further, and that is why it is unlawful to cut, pick or destroy sea oats. Where we as a species have really done the greatest damage is in our relentless building and landscaping. Edisto is fortunate indeed that builders and developers have, perhaps more here than on other South Carolina beaches, avoided building houses and buildings on top of the primary dunes. Pictures of hotels on the beach at ocean's edge, barricaded by huge sea walls and boulders, their seaside swimming pools already lost to erosion, provide graphic evidence of what happens when man ignores the ecological realities of his environment.

If we want to have a beach where our grandchildren can experience the joys that we have, it is incumbent on us all that we treat the dunes and grasses with deference and respect, and that we urge our lawmakers to demand that developers do the same. Once the beaches are gone, it will be too late.

THE MARSH

If the dunes are the armor for the island, the marsh is its womb. It is here that fish, shrimp, crabs, birds and other species breed and grow, and where the plants and other animals that will feed these important parts of our food chain are nurtured.

Marsh is defined as low land, sometimes covered with water, where Spartina and other marsh grasses grow, and where trees and other species indigenous to high ground cannot grow. At Edisto, these marshes are fed and sometimes flooded by the tidal creeks. Visits to the marsh will yield spectacular views of

birds such as herons and egrets, and where the tidal creeks wander through the marsh, an opportunity to see or catch fish, shrimp or crabs.

Although the techniques for those activities are covered elsewhere in this book, there are two observations that are appropriate here. The first concerns the smell of the saltmarsh. To the uninitiated, this pungent odor may seem offensive, even overwhelming. This is the smell of life and death as they are inextricably joined. Life, in the form of chlorophyll produced by plankton, Spartina and other plant forms as they grow and generate oxygen, using carbon dioxide and other waste products as their diet. Death, in the release of ammonia compounds and nitrogen from the decomposition of plant and animal life.

Additionally, there is the aroma of the saltwater itself, which contains such components as sodium chloride (salt), calcium, magnesium, potassium and lime. Also present is hydrogen sulfide, the "rotten egg" smell you may remember from chemistry class as sulphur. Together they make the distinctive smell that those of us with a love for this island find synonymous with the marsh's great bounty of food and beauty.

The other observation has to do with pluff mud. While there are other types of mud in the marsh (as you will discover the first time you slip on the incredibly slick mud of a creek bank), pluff mud is deserving of a special mention. First, it is the repository for the sulphur referred to above and that odor will be released when you step down into it.

Second, when you step down into it for the first time, you are going to remember every Tarzan movie you ever saw as a child and you'll probably be convinced that you have discovered some hideous new mutation of quicksand. You will probably also lose your brand-new pair of sneakers—or worse yet, only one of them. (This will make you redouble your efforts to recover the other one.) Welcome to the marsh!

Edisto: A Guide to Life on the Island

Pluff mud (also referred to as "plough mud," "marsh mud," "muck" and several other names not fit for printing) is formed when the decayed plant and animal life mixes with waste and mud from topsoil. To this group is added the presence of anaerobic bacteria that lives and then dies, and in death produces the hydrogen sulfide gas we find so noxious. The fine particles of "mud" that result from this process have a fairly low specific gravity because much of the mass of the mud is gaseous.

I hope this helps you to understand why, when you step into a particularly deep old accumulation of pluff mud, you're going to think you'll sink in over your head, and the smell will be so bad you'll hope you go quickly. By the way, if you were foolish enough to wear your new sneakers after reading this, you deserve to have to buy a new pair.

The Living Things

There are probably few places in the continental United States where a person so inclined can see as many species of flora and fauna as on Edisto Island. While this book does not purport to serve as a nature guidebook, a discussion of some of the living things you may see on the island can help your enjoyment of your time here, and so the following is offered with the hope that you will use this chapter merely as a starting point for a lifetime of appreciation of God's natural wonders.

SEA LIFE

The South Atlantic Ocean and the waters of the North and South Edisto River and her creeks hold untold thousands of species of plants and animals. One of the most exhilarating species to watch is the Atlantic bottlenose dolphin. Sometimes inaccurately called a porpoise (a four- to six-foot creature with a blunt nose, whose habitat is from Delaware northward), the dolphin is a cetacean (a toothed whale) and ranges in length from seven to twelve feet. It is gray, has a three-inch snout that extends from its skull and a dorsal fin that curves back. It is often seen in large creeks, rivers and the ocean, cavorting singly, in pairs or in schools. Like other whales, it must surface to breathe and can be witnessed "blowing steam" as we used to call it when we were kids. The graceful curving loops that the dolphin makes

as it breaks water while swimming may be one of the most delightful sights you'll see at Edisto.

Also plying the waters and of great interest are some of the curiosities of the deep. Included in this category are octopus, squid, rays (skates, stingrays and manta rays), corals, starfish, sand dollars, seahorses, jellyfish, sponges, sea anemones, sea cucumbers, various seaweeds, sea pork, sea roaches and clamworms.

Then there are the many crabs that can hold a child's attention for hours. Among them are the Atlantic blue crab (the tasty, edible one), the fiddler, ghost, hermit, lady, mole, oyster, purse, speckled, spider and stone crabs. Perhaps the most fascinating crab for children is not a crab at all. The horseshoe crab is actually more closely related to the spider or the scorpion and has remained relatively unchanged for approximately 150 million years!

Fish that you may catch on your hook, in your net, or at local restaurants include flounder, channel bass, spotted sea trout, croaker, whiting, spot, blackfish, cobia, Spanish and king mackerel, grouper, snapper, tilefish, dolphin (the fish, not the mammal; also known as mahi mahi or dorado), bluefish, marlin, barracuda, catfish, toadfish, mullet, spiny boxfish and a multitude of others.

BEACH LIFE

Many of the plants and animals you will observe on the beach are, of course, cast up out of the ocean. All of the shells you find were once living creatures of the deep; so were the seaweeds and corals; and likewise the fossils were part of either denizens of the sea or land creatures (see the section on Beachcombing elsewhere in this book).

There are two interesting ways to get a closer look at the life of the ocean and beach. One is to search out a tidal pool as the tide drops from high to low. In it you will find living organisms of many types. It is not unusual to spot sea cucumbers and anemones, sand dollars and starfish, mole crabs and lugworms, minnows and shrimp and donax by the thousands. One of my grandmother's games for us grandchildren on a rainy day was to paste donax shells onto construction paper. Donax, you see, come in every imaginable color, and so became our palate for our pictures. (Note: only use the half shells. We would boil the live ones until the shells opened, revealing their richly colored insides.)

The other method is to go out on the beach at night. Clear, moonlit nights are the best, for they allow you to observe the nocturnal life without disturbing it. Should this not be possible, you can use a flashlight, but you should try not to interfere with any creatures you find, especially sea turtles. While on the night beach, look for ghost crabs. They are as small as a dime or as large as a jar lid, are light in color, and are extremely fast. They usually come out at night, and spend their days in those holes you may have seen on the beach that look like snake holes.

LOGGERHEAD SEA TURTLES AND THE EDISTO BEACH LOGGERHEAD SEA TURTLE PROJECT

As mentioned above, you may be lucky enough to see a sea turtle on the beach at night. These animals are about three and a half feet long and weigh around 350 pounds. They come up onto Edisto Beach between May and August to lay approximately 120 leathery little eggs resembling ping-pong balls in nests approximately two feet deep. In about two months, the eggs that survive high tides, erosion, raccoons and man will hatch into

silver-dollar-sized hatchlings, which will then try to find their way back to the ocean. Only one in ten eggs laid will hatch and only one in ten thousand hatchlings will survive to maturity. Because odds are stacked so heavily against the turtles, the Edisto Island Sea Turtle Project (EISTP) was started in 1981. The original objective of counting crawls and nests and developing a management plan for this threatened species expanded to nest protection and public education. Now, the Town of Edisto Beach operates the Edisto Beach Loggerhead Turtle Project.

Turtle Project volunteers walk the beaches of Edisto every day during the nesting season to spot crawls and identify nests. The little yellow, blue or red flags you may see near the dunes are the markings of turtle crawls or nests and should not be disturbed. One of the most exciting experiences you may ever have is to see the little hatchlings dig out from their sandy nests and flap themselves down the beach and into the surf. Should you be so fortunate, please leave the baby turtles alone: they need to get to the ocean on their own (some biologists theorize that it is in this way that they imprint the directions they need to return to lay their own nests twenty or more years later), and the only help you should render is to turn them around and get them headed to the beach if they become confused and head for Palmetto Boulevard. And please, keep your outside lights off at night during the nesting and hatching season (mid-May to mid-October), as these lights are confusing and disorienting to both mother and hatchling.

Birds

Hundreds of species of birds have been identified on Edisto and you are an odd bird yourself if you are not captivated by the antics of the gulls, the lazy

formations of pelicans or the grace and beauty of the great blue herons and the long white egrets. Other birds you may have the pleasure of watching are loons, coots, cormorants, bitterns, ibises, many species of ducks, sandpipers, terns, plovers, hawks, swallows, wrens, rails, oystercatchers, black skimmers, kestrels, warblers, chickadees, mockingbirds, cardinals, blue jays, bluebirds, eagles, cedar waxwings, grackles, fish crows, cowbirds, red-winged blackbirds, woodpeckers, owls, ospreys and dozens of others.

The male painted bunting, by far the most colorful bird I have ever seen, is one that I have had the pleasure of seeing numerous times on Edisto (but which I've never seen off-island).

OTHER ANIMALS

While on Edisto it may be your good fortune to spot many animals rarely seen outside of zoos. A partial list of those I have seen include deer, opossums, raccoons, river otters, red fox, wildcats, cotton rats, snakes, lizards, alligators, tree frogs, luna moths, rabbits and butterflies in swarms of thousands.

Should you desire to see some of Edisto's animals, all you need do is look around you. If the only animals you see are the ones throwing the toga party next door, allow me to suggest you contact the State Park. The good folks there can direct you to their self-interpretive trail and their four-mile hiking trail. They can also tell you if the park's naturalist will be lecturing or leading any nature hikes.

Next page: Palmetto sunrise at Edisto Beach State Park. *Photograph by Susan Roberts.*

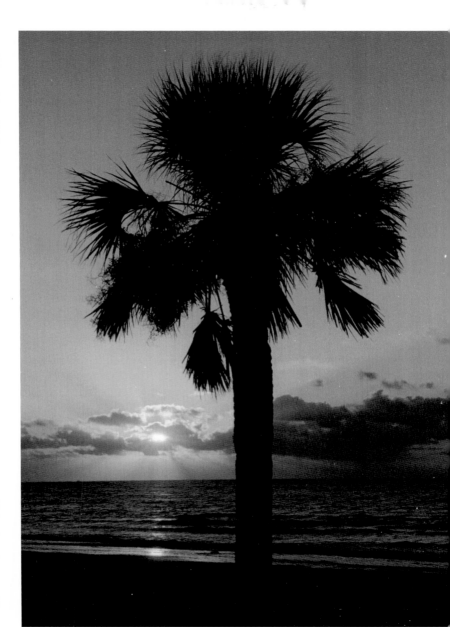

Hurricanes

Hurricanes are cyclones caused by very low barometric pressure. Their characteristic center, or eye, is an area of relative calm encircled by powerful winds and storm. Once a tropical cyclone reaches winds of seventy-four miles per hour, it is technically called a hurricane. The National Hurricane Center in Miami, Florida, keeps track of storm formation using all types of monitoring devices to determine location and wind velocity. The center then broadcasts information needed by local weather officials to track the progress of the storm and to take the proper steps to warn citizens and visitors of a hurricane's approach.

As we have learned from hurricanes like Katrina, Andrew and Hugo, the entire area affected by a hurricane is often several hundred miles across, with an area of maximum destruction about fifty miles wide. Hurricanes lose much of their strength if and when they make landfall; however, they often spin off tornadoes.

A hurricane needn't be very strong, though (or very close by), to cause heavy rains, flash floods, coastal inundation and abnormally high tides and wind damage. Although strong winds are the hurricane's trademark,

Edisto: A Guide to Life on the Island

its greatest threat to life and property is often from flooding caused by tidal surges.

In the last one hundred years, Edisto has been affected by numerous hurricanes and devastated by three. In 1893, a hurricane came ashore at Edisto and destroyed the Bay, the summer beach settlement on the Edingsville Beach portion of the island. Again in 1940, hurricane winds and waters hit the island, this time destroying or severely damaging all but a handful of houses. Most recently, in 1959, Hurricane Gracie plowed into Edisto ruining many homes and doing hundreds of thousands of dollars of property damage. Smaller hurricanes have affected Edisto, though not hitting it dead on. In 1989, Hurricane Hugo looked to be on a track to hit Edisto or just south of it, but veered just before landfall and hit Charleston, forty miles to the north.

Bibliography and Suggested Reading List

Note: Some of these works are long out of print; some have been privately republished. Some of them are available at the Charleston County Public Library and its Edisto Island branch.

Ames, Mary. *She Came to the Island.* Edisto: Sea Side Services, 1982.

Amos, William H. *The Life of the Seashore.* New York: McGraw-Hill, 1966.

Ballentine, Todd. *Tideland Treasure.* Hilton Head, SC: Deerfield Publishing, 1983.

Cerruti, James. "Sea Islands: Adventuring Along the South's Surprising Coast." *National Geographic* 139, no. 3, March 1971.

Clarke, Reverend Philip G. Jr. *Anglicanism in South Carolina 1660–1976.* Easley, SC: Southern Historical Press and Reverend Emmett Lucas Jr., 1976.

Cottrell, Ernest J. et al. *Successful Crabbing.* Camden, Maine: International Marine Publishing Co., 1976.

Evanoff, Vlad. *How to Fish in Salt Water.* New York: A.S. Barnes, 1962.

Edisto: A Guide to Life on the Island

Fick, Sarah. "Historic School Buildings on Edisto Island." *Preservation Progress—For the Preservation Society of Charleston*, Summer 1994.

Graydon, Nell, *Tales of Edisto*. Columbia, SC: R.L. Bryan Co., 1955.

Howe, George, D.D. *History of the Presbyterian Church in South Carolina*, Vols. I & II. Columbia, SC: Duffie & Chapman, 1870.

Johnstone, Kathleen Yerger. *Collecting Seashells*. New York: Grosset & Dunlap, 1970.

Kenner, Helen C. *Historical Records of Trinity Episcopal Church*. Raleigh, NC: Dorsett Printing Company, 1975.

Lindsay, Nick. *An Oral History of Edisto Island: Sam Gadsden Tells the Story*. Goshen, IN: Pinchpenny Press, 1975.

———. *An Oral History of Edisto Island: The Life and Times of Bubberson Brown*. Goshen, IN: Pinchpenny Press, 1977.

Mikell, I. Jenkins. *Rumbling of the Chariot Wheels*. Columbia, SC: The State Co., 1923.

Murray, Chalmers S. *This Our Land*. Charleston: Charleston Art Association, 1949.

———. *Here Come Joe Mungin*. New York: G.P. Putnam's Sons, 1942.

Murray, J.G. *The Murray Family of Edisto Island*. Greenville, SC, 1958.

Petit, James Percival. *S.C. & The Sea: Day by Day Toward Five Centuries*, Vol. I. Charleston: Maritime & Ports Activities Committee, 1976.

Potter, Eloise F. et al. *Birds of the Carolinas*. Chapel Hill: University of North Carolina Press, 1980.

Puckette, Clara Childs. *Edisto, A Sea Island Principality*. Cleveland, OH: Seaforth, 1978.

Ramsay, David. *History of South Carolina, from Its Settlement in 1670 to the Year 1808*. Newberry, SC: W.J. Duffie, 1858.

Rogers, Julia Ellen. *The Shell Book*. Boston: Branford, 1908.

Rutherford, Summer. "Working on Edisto Time: Preservation and Community Values, A Study of Edisto Island for The Preservation Society of Charleston and the Addlestone Foundation for Low Country Studies." *Preservation Progress—For the Preservation Society of Charleston*, August 1992.

Seabrook, Whitemarsh B. *Seabrook's Memoir on the Origin, Cultivation and Uses of Cotton*. Charleston: Miller and Brown, 1844.

Stephens, William M. *Southern Seashores*. New York: Holiday House, 1968.

Edisto: A Guide to Life on the Island

Tindall, Frances. "Interview with the Belle of Brick House." *Preservation Progress—For the Preservation Society of Charleston*, Summer 1994.

Whitelaw, Robert N.S., and Alice F. Levkoff. *Charleston—Come Hell or High Water.* Charleston, 1976.